Copyright © 2016 Apparition Studios
All rights reserved.
ISBN: 1537403486
ISBN-13: 978-1537403489
HorridColoringBooks.com

Dahlia's Decrepit Dolls

Coloring Book

By:

Jordan R. Colton

Dearest Abigaile,

Hello my dear cousin. I hope that this letter and present finds you well. Lilly and I are so excited to share with you the drawings we made for you of all of our friends!

Father always has a new friend for me whenever he comes back home after being gone for so long.

I hope you love the drawings I made of my dolls. I will have to share with you the stories Father would tell me of each of these dolls as he found them during his investigations.

Some were found at some of the most gastly murders you probably have read about in the papers. Including one of the Jack the Ripper murders in Whitechapel.

I love every single one of these dolls but some strange things have begun to happen in the house as my collection of dolls has grown. I hope it stops soon....

Your Cousin

Dahlia ♡

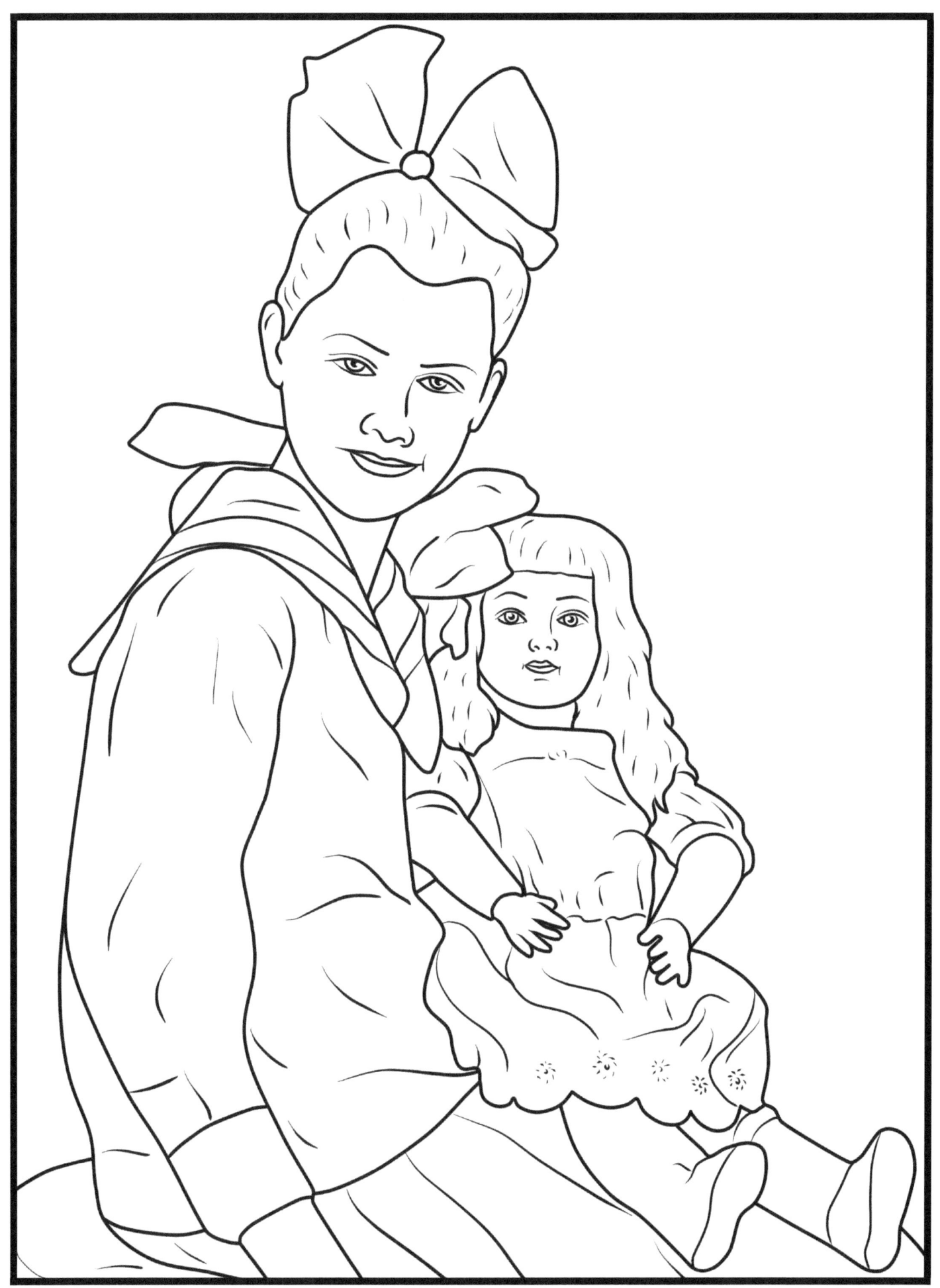

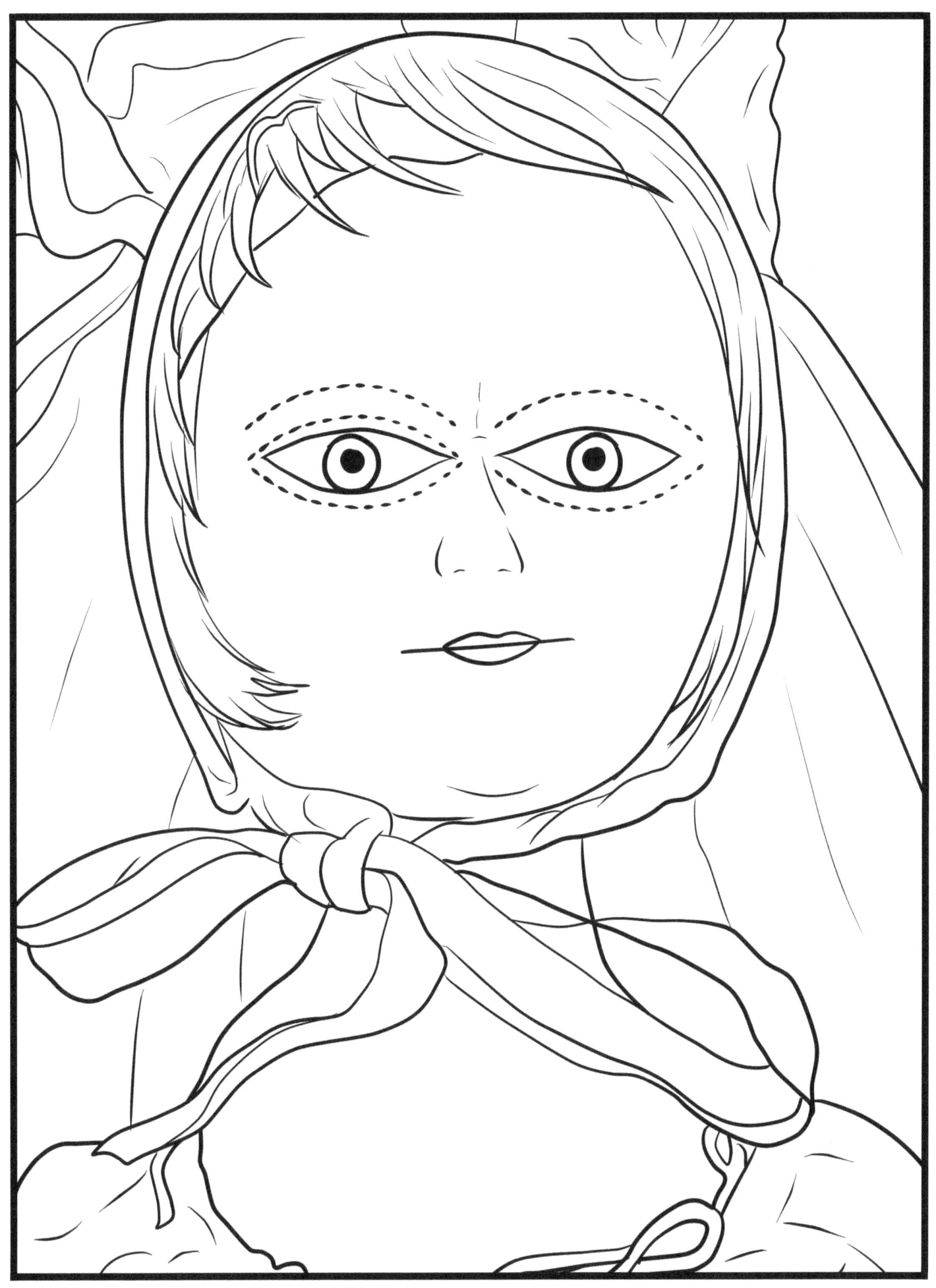

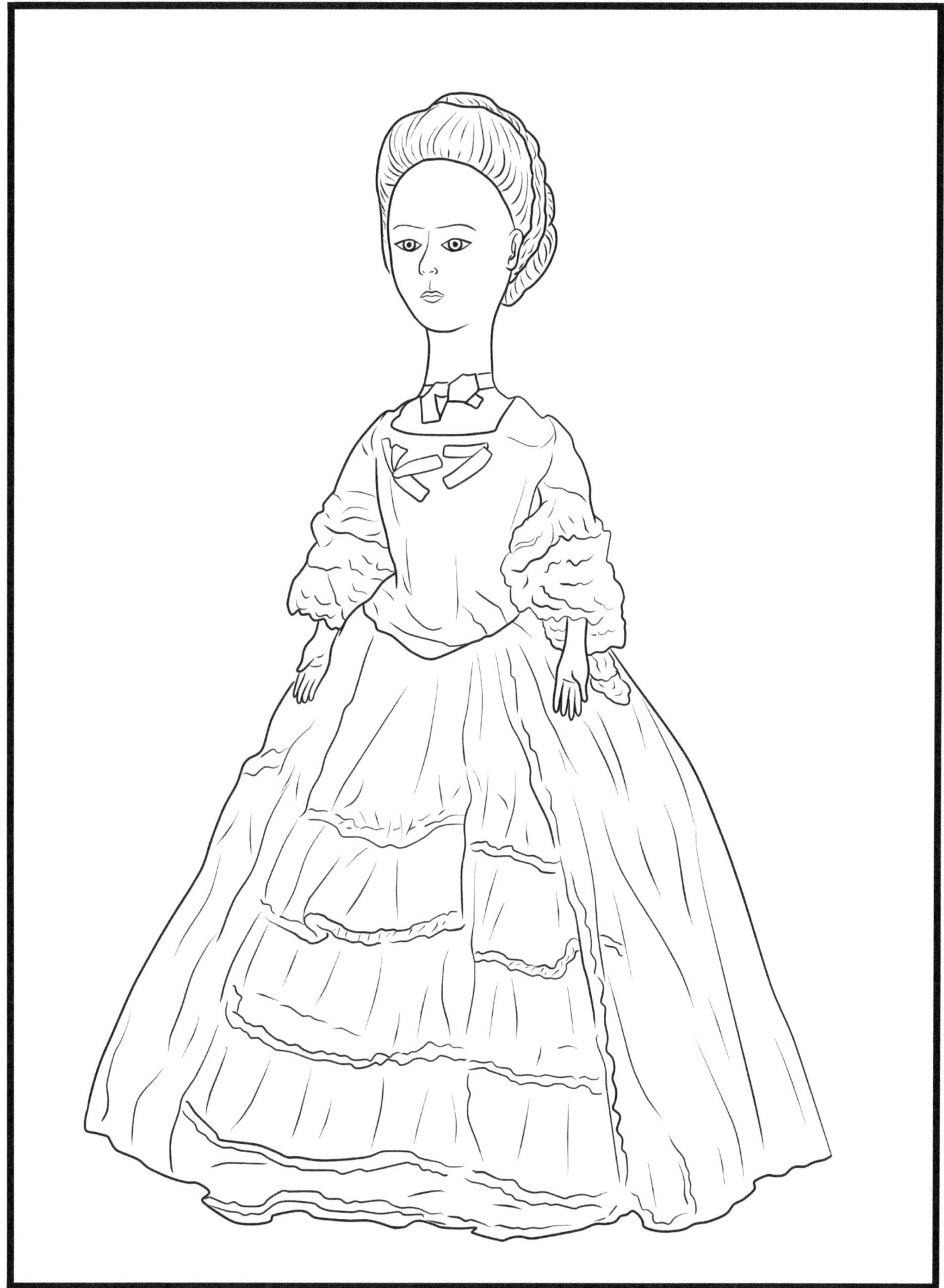

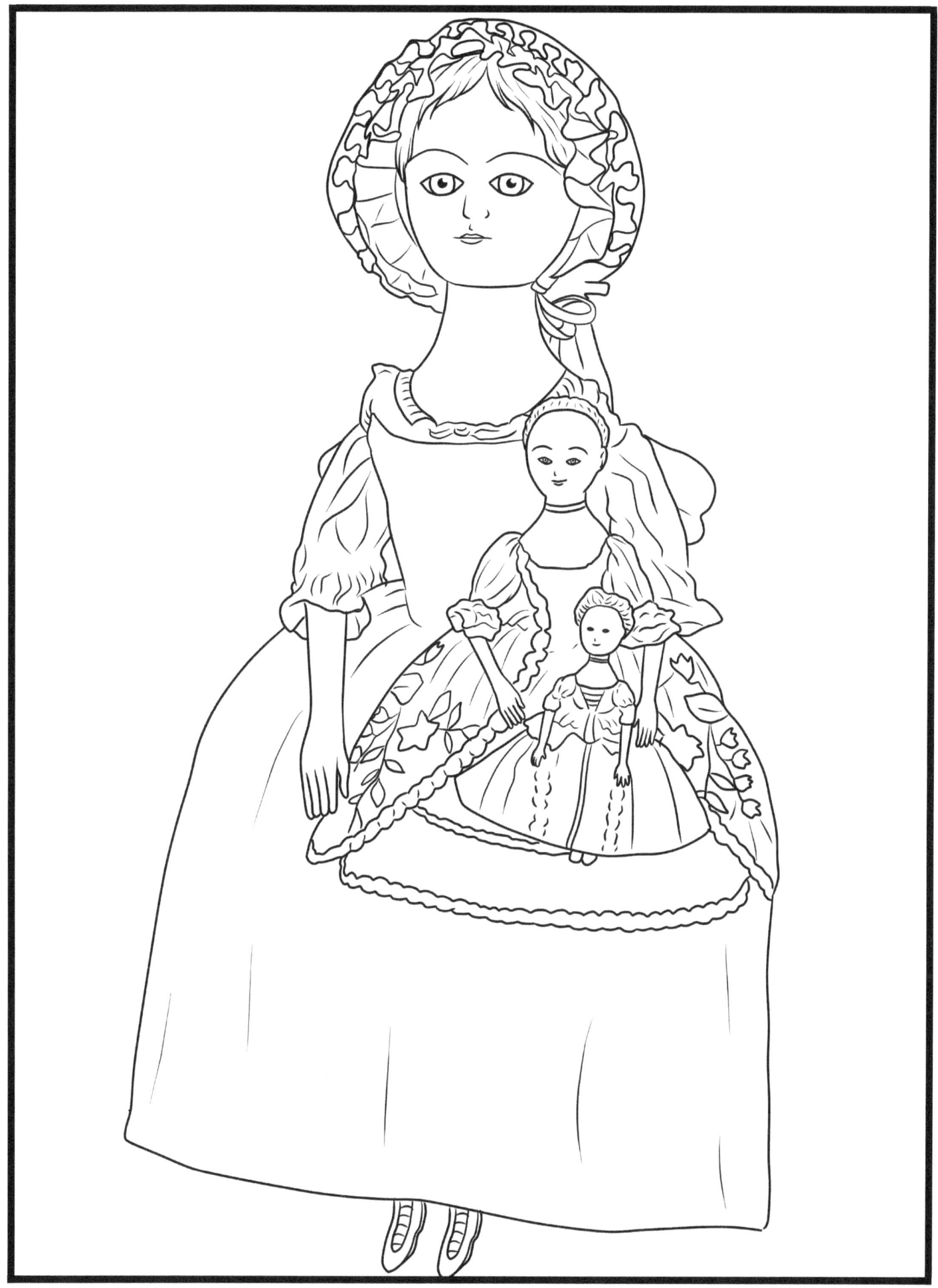

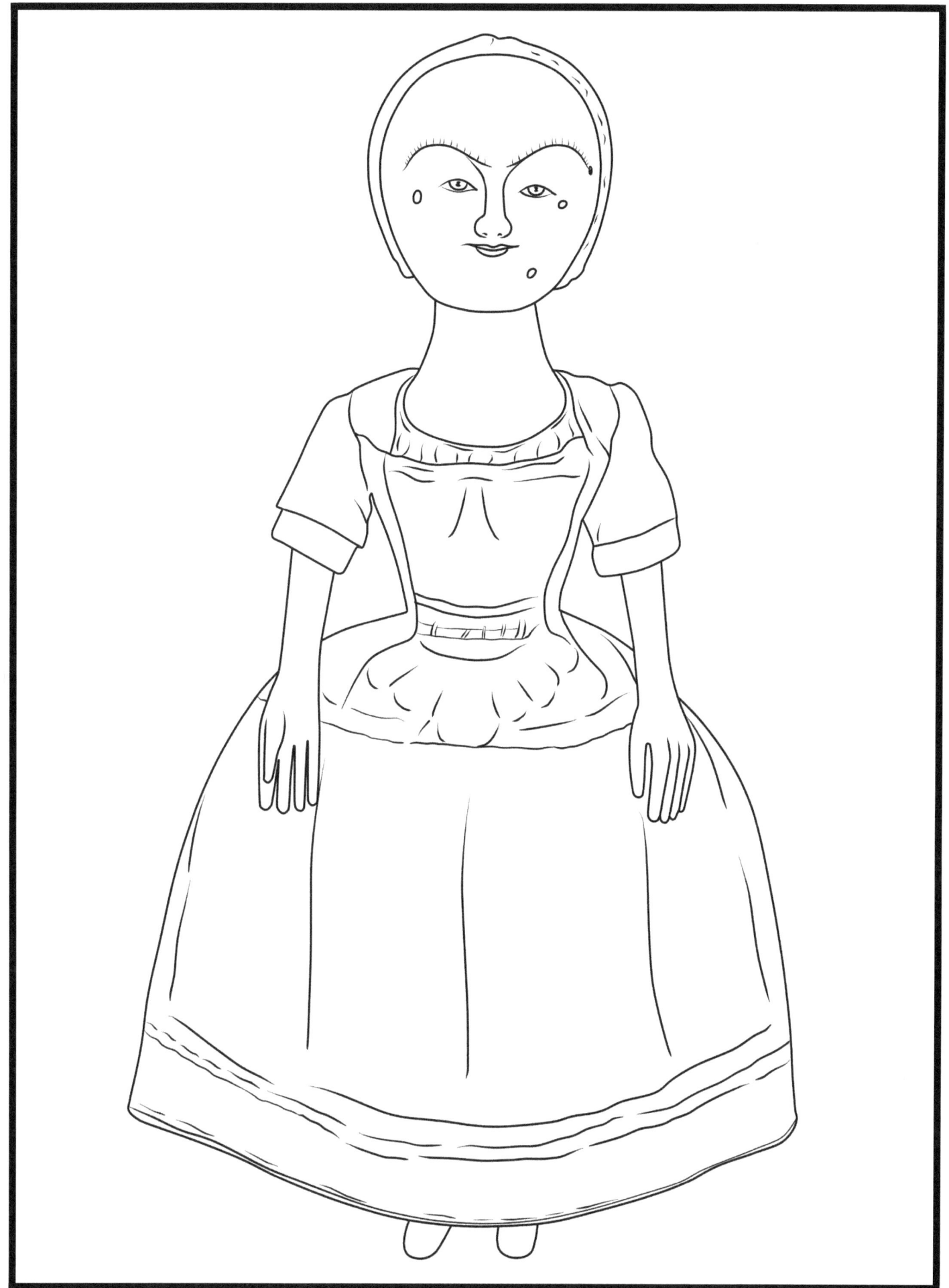

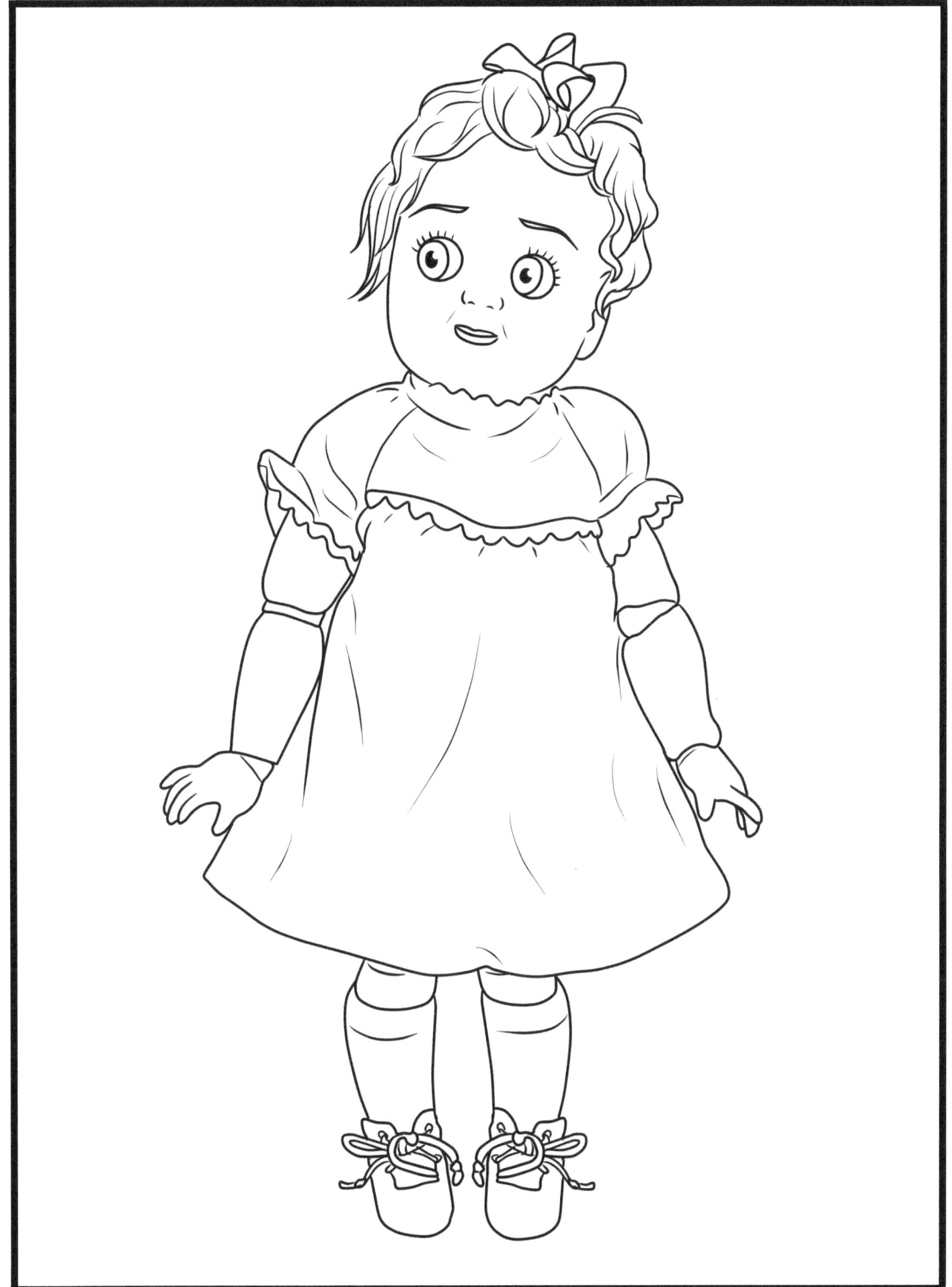

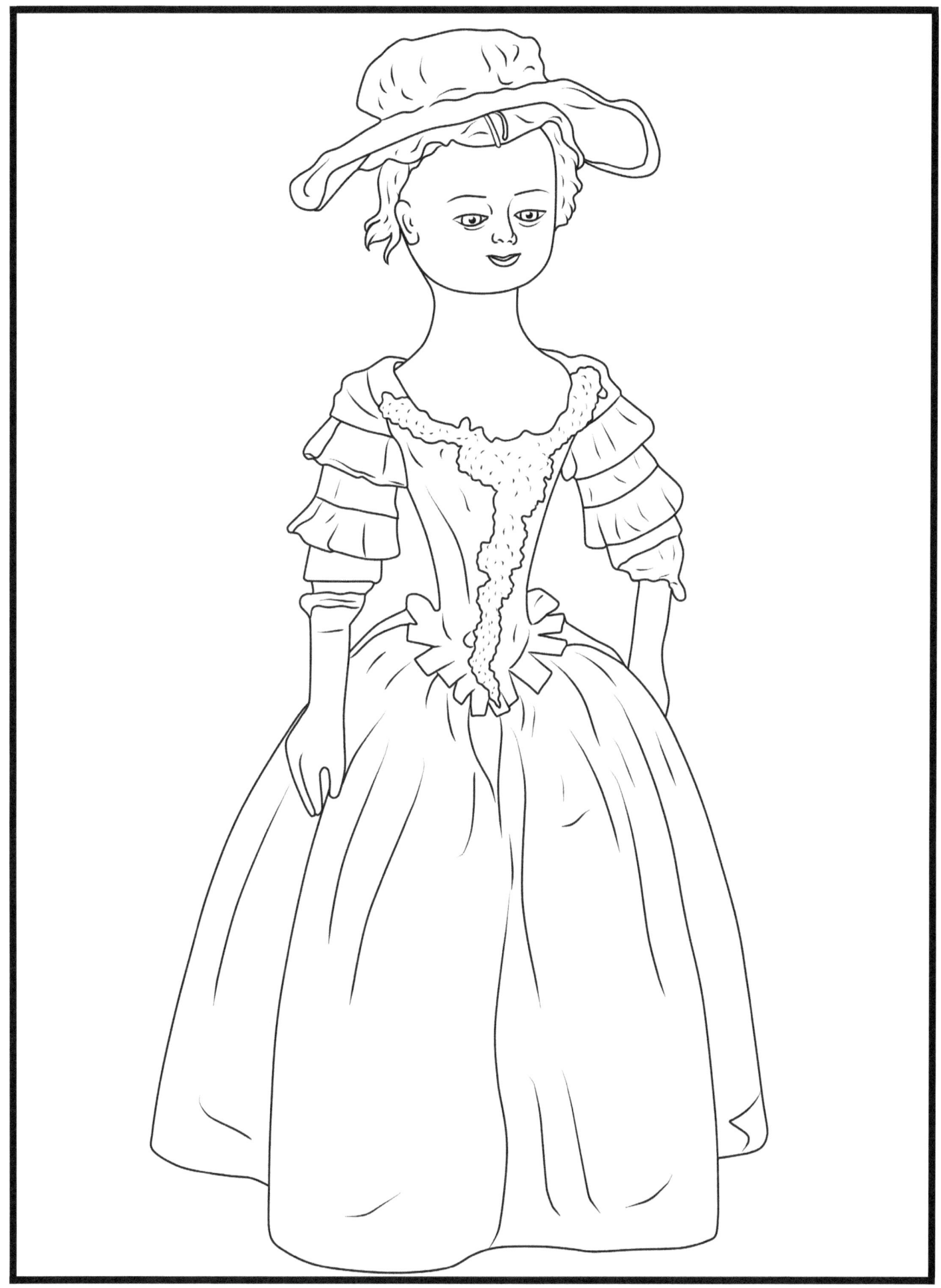

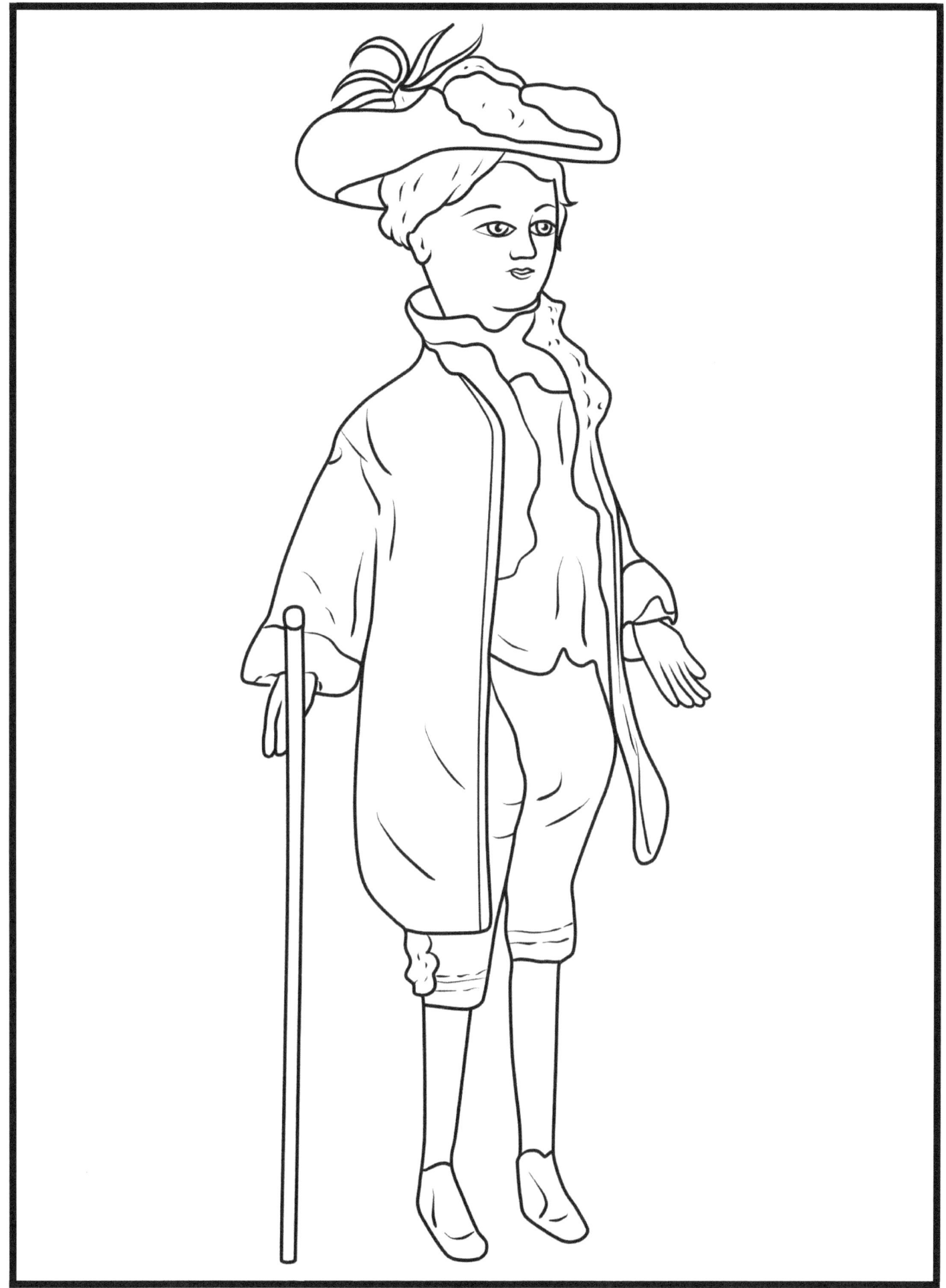

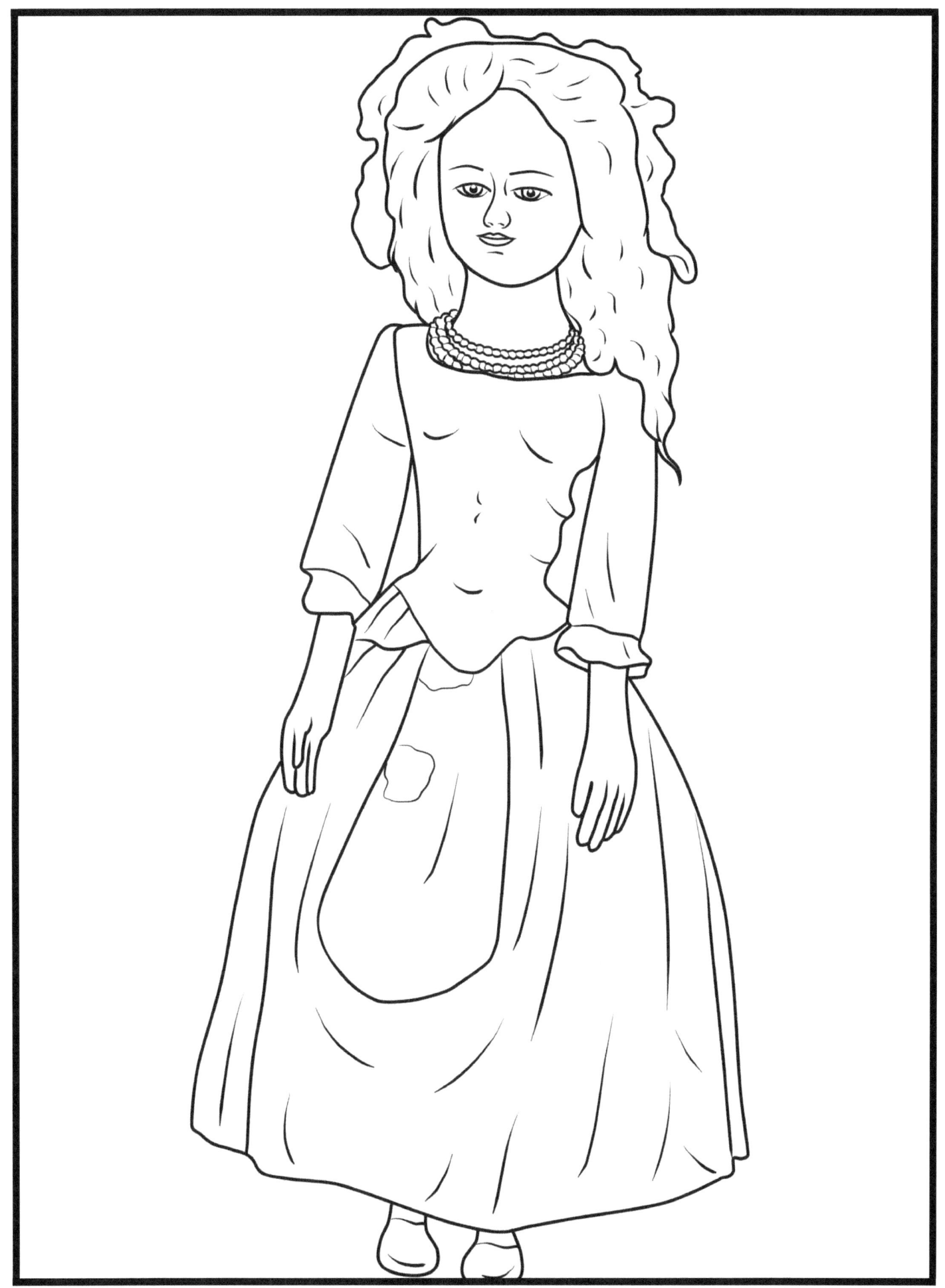

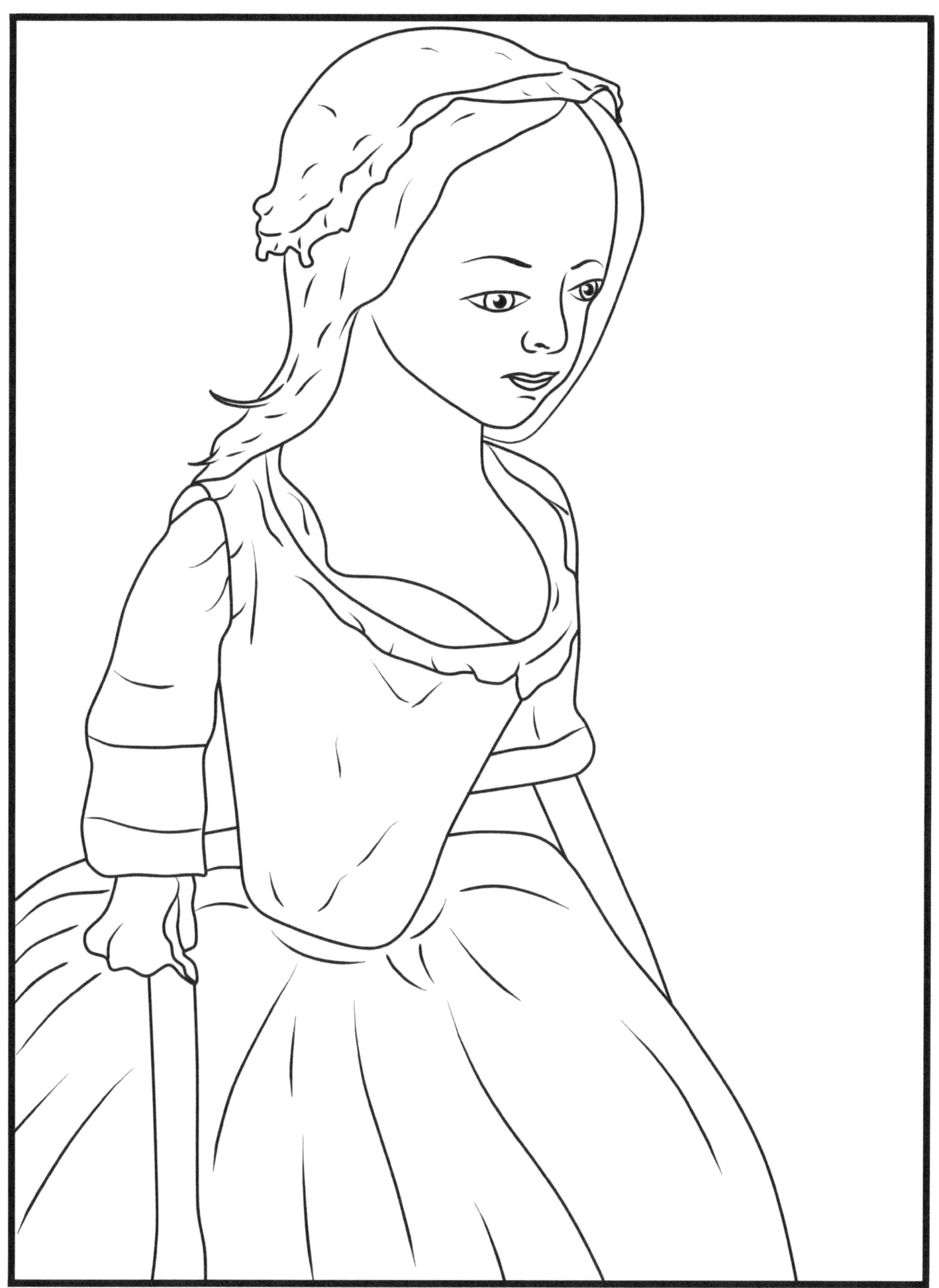

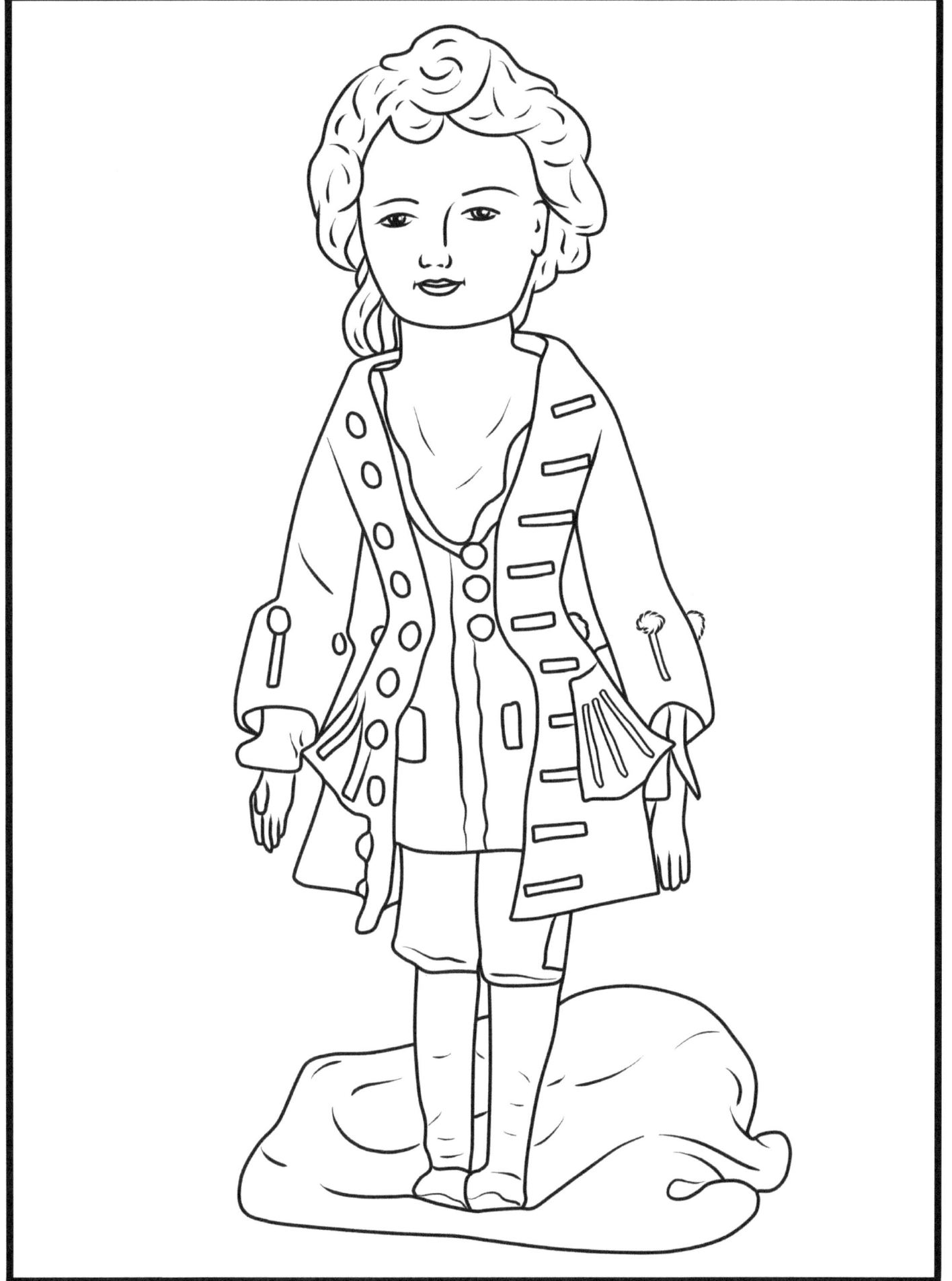

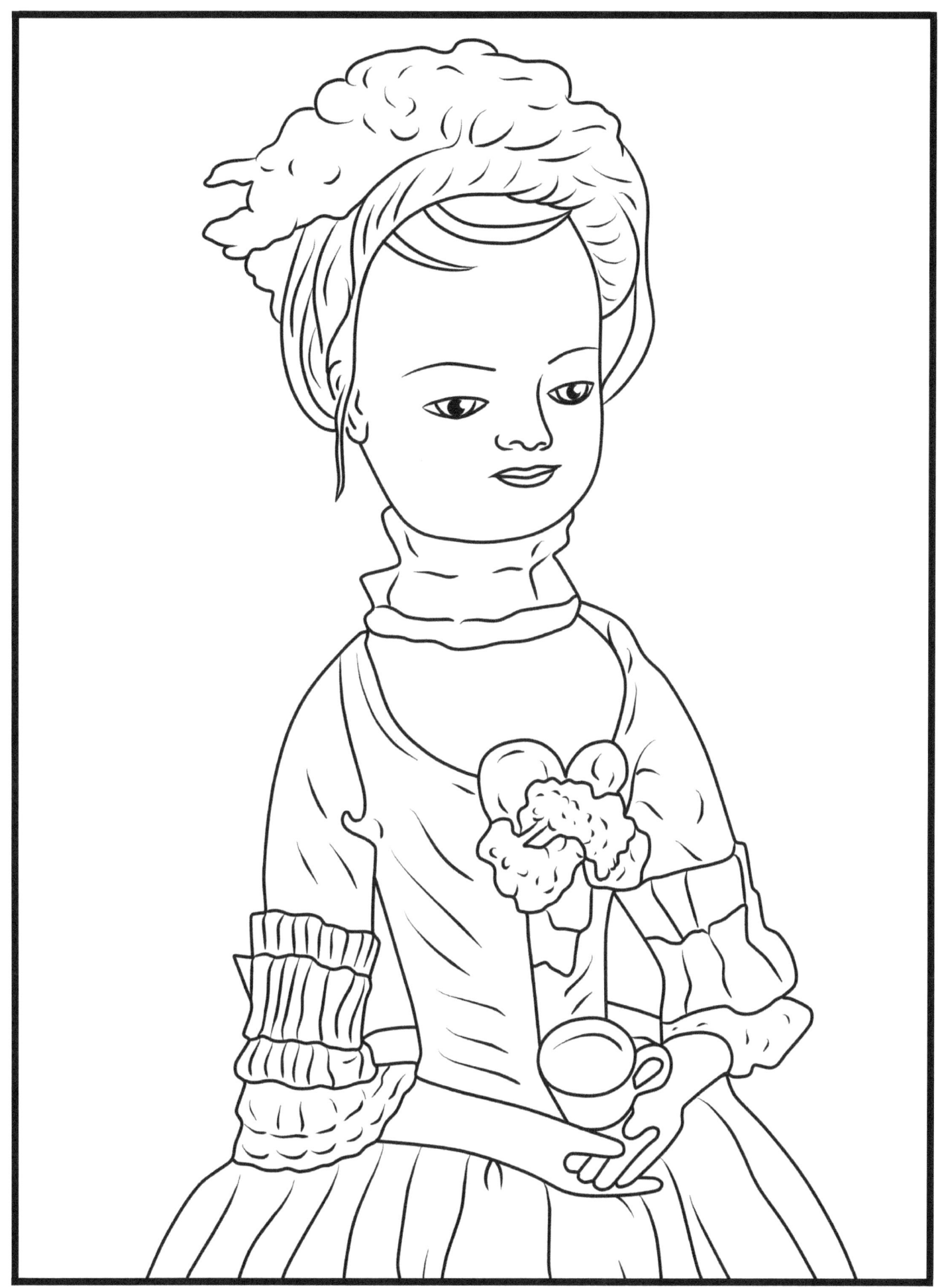

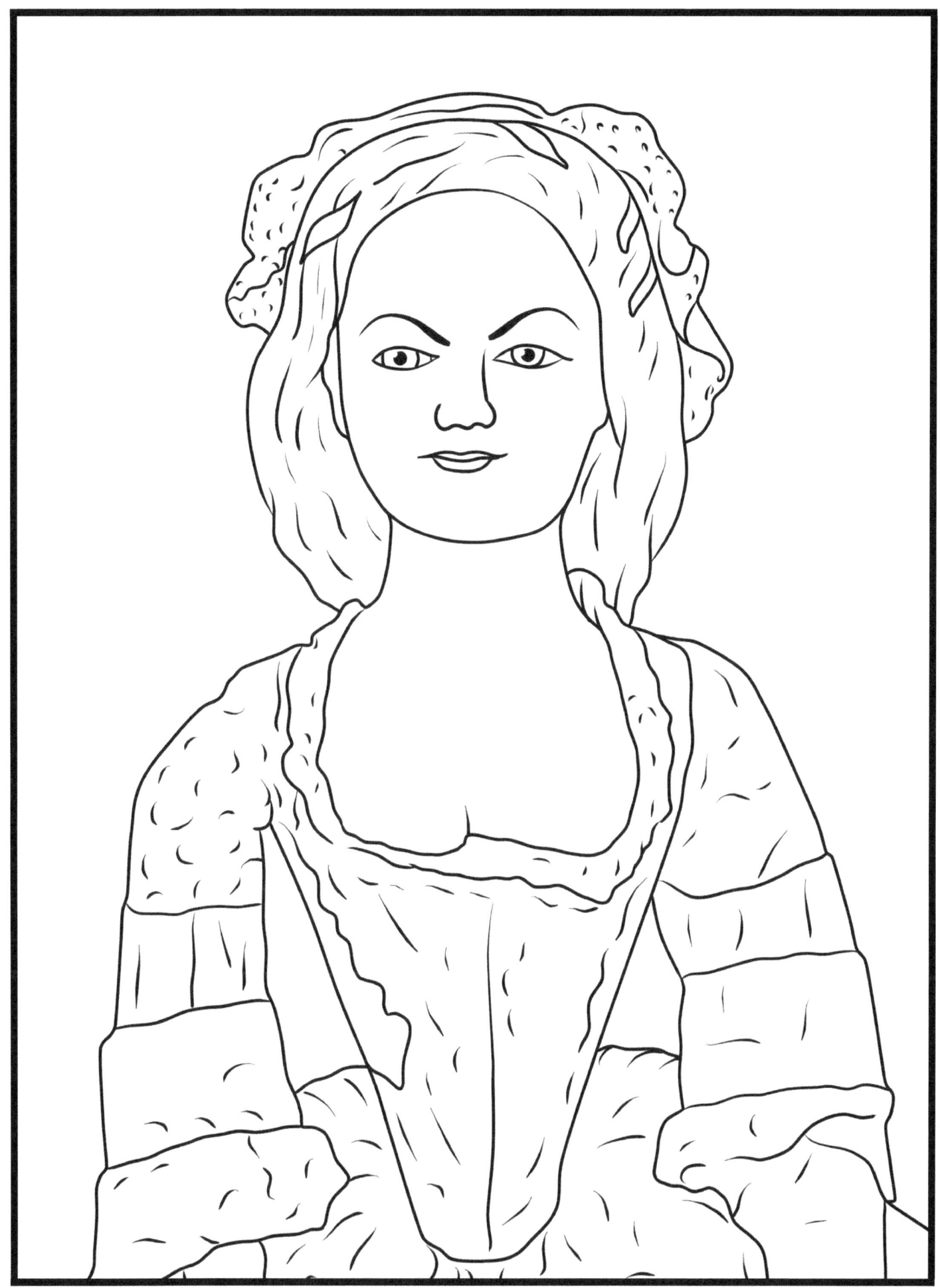

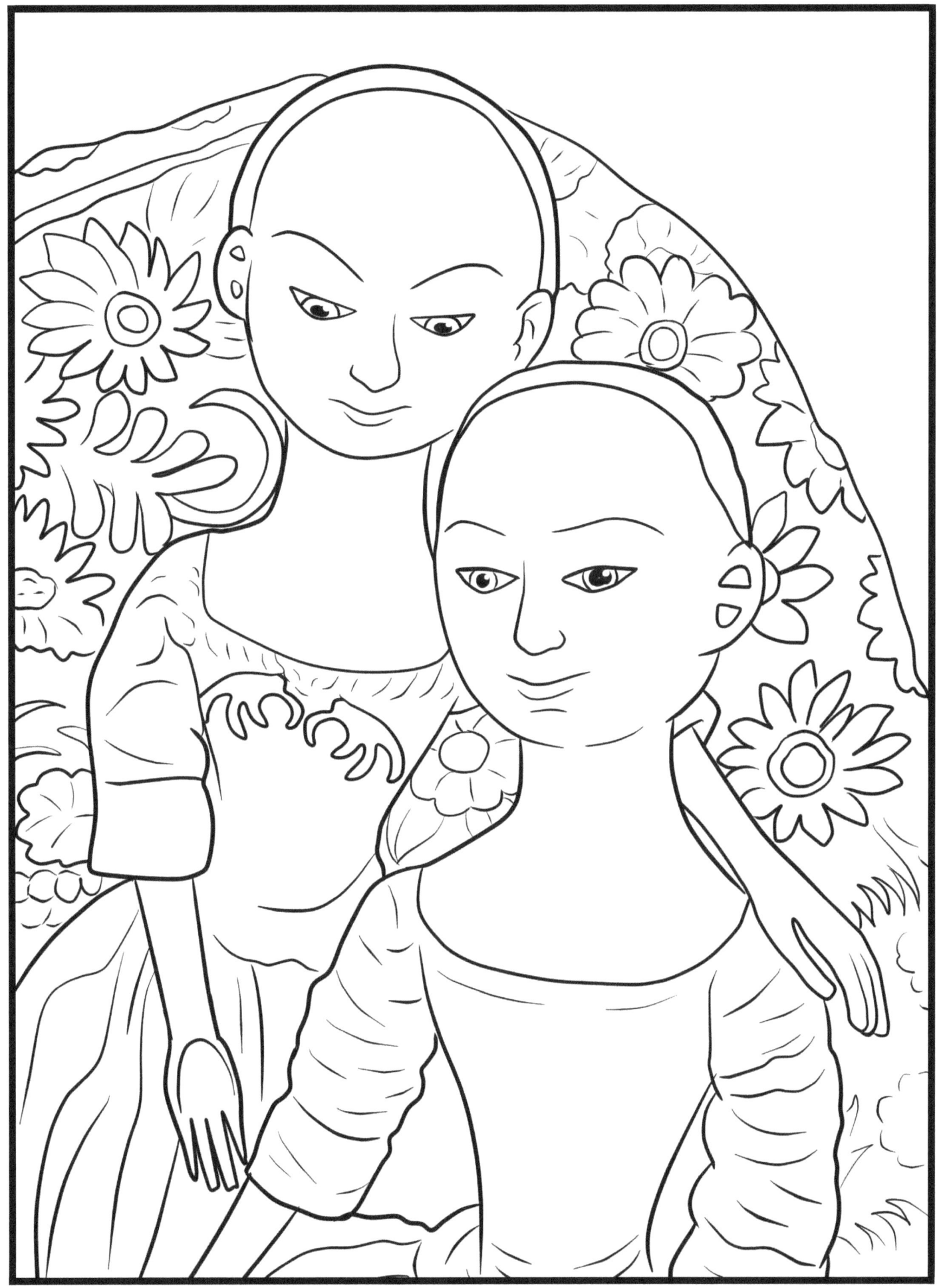

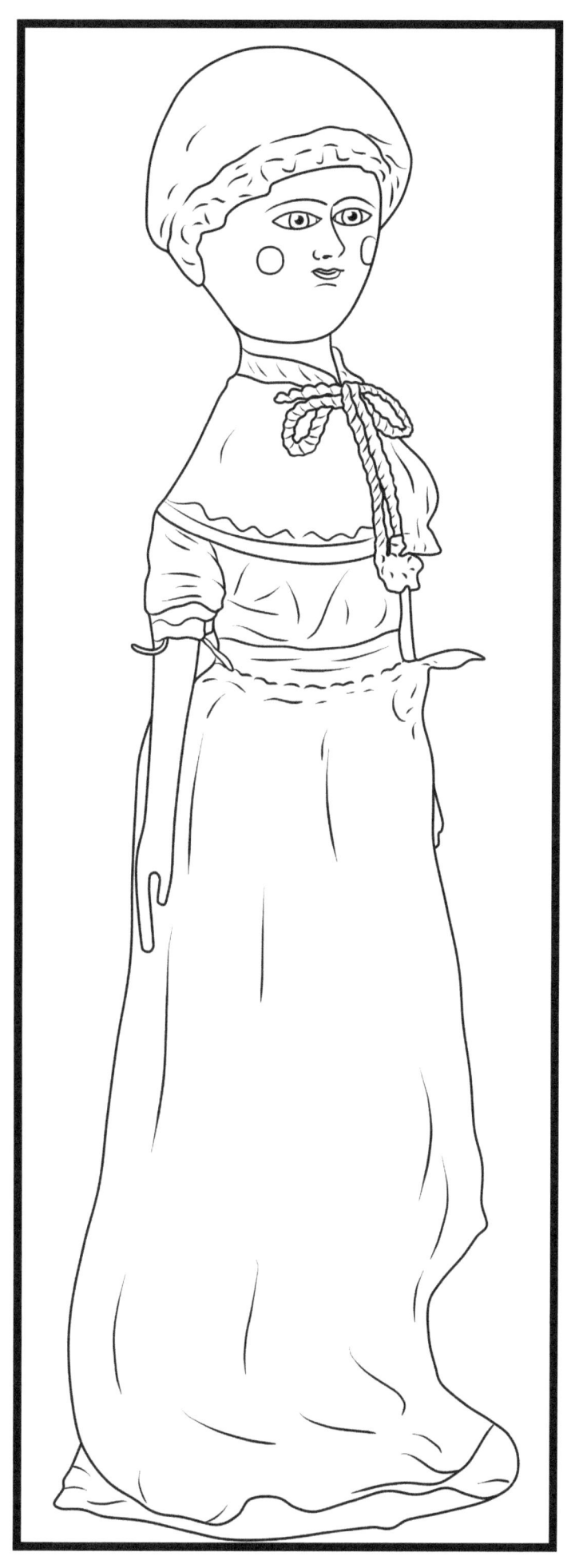

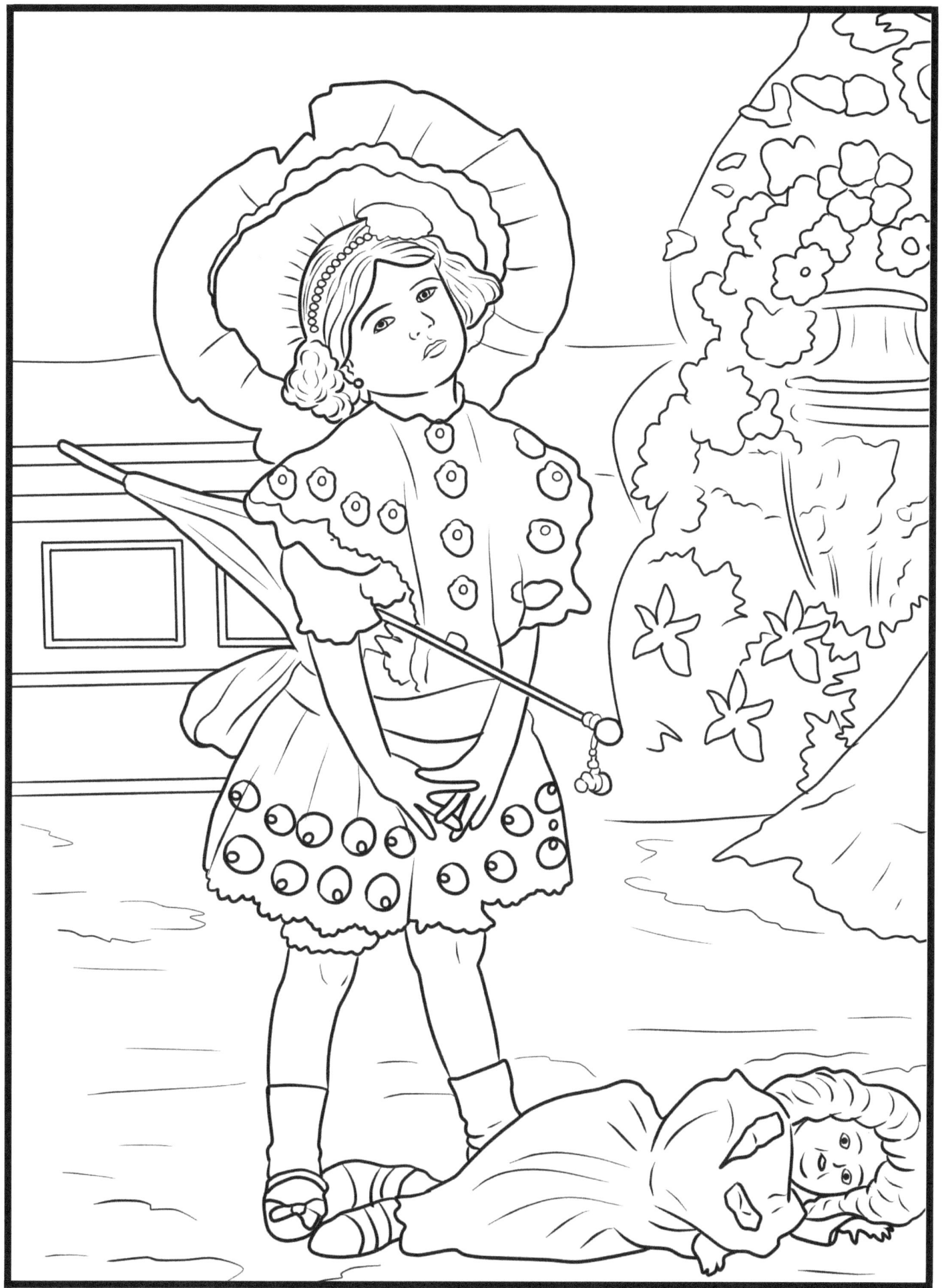

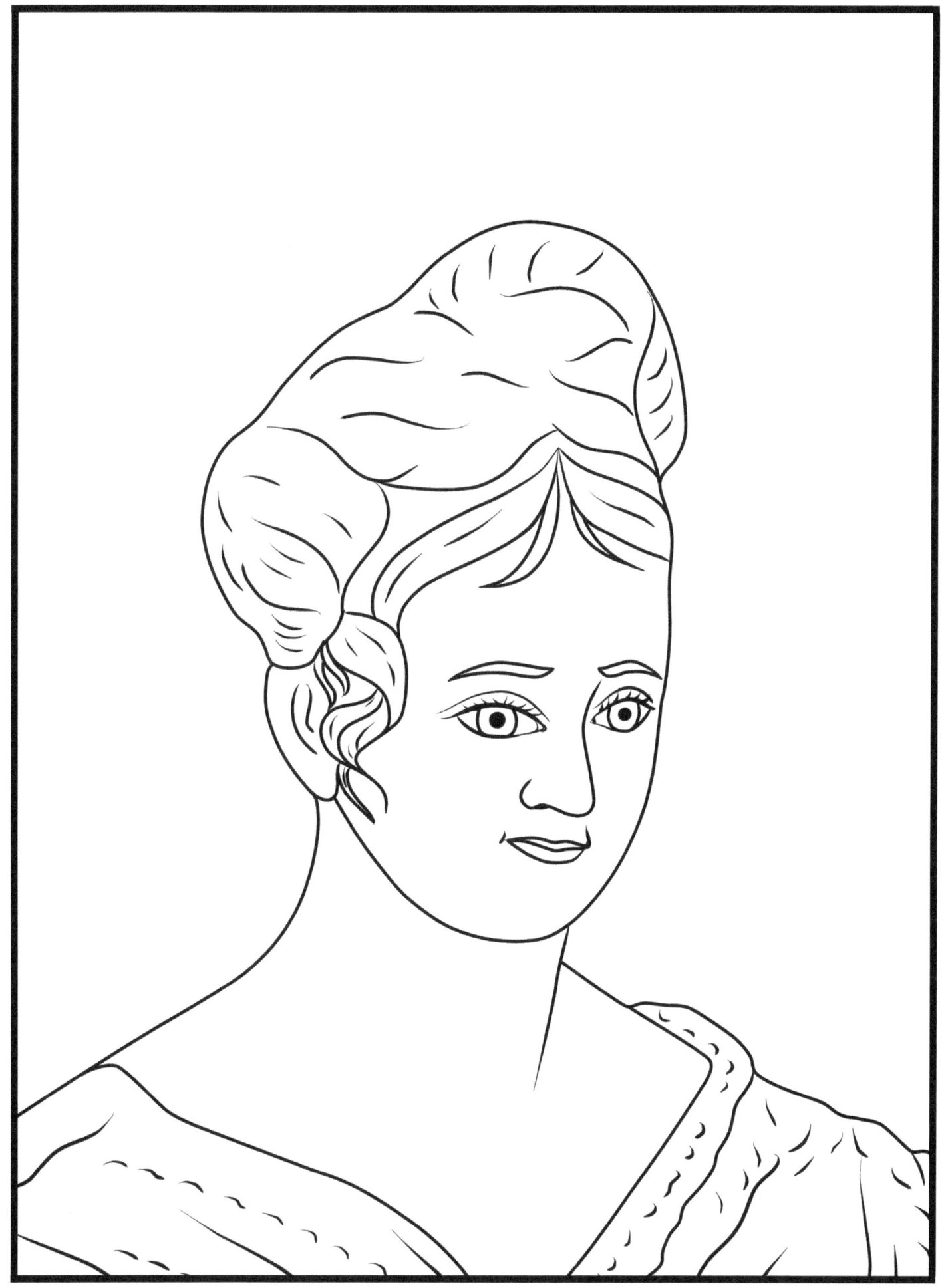

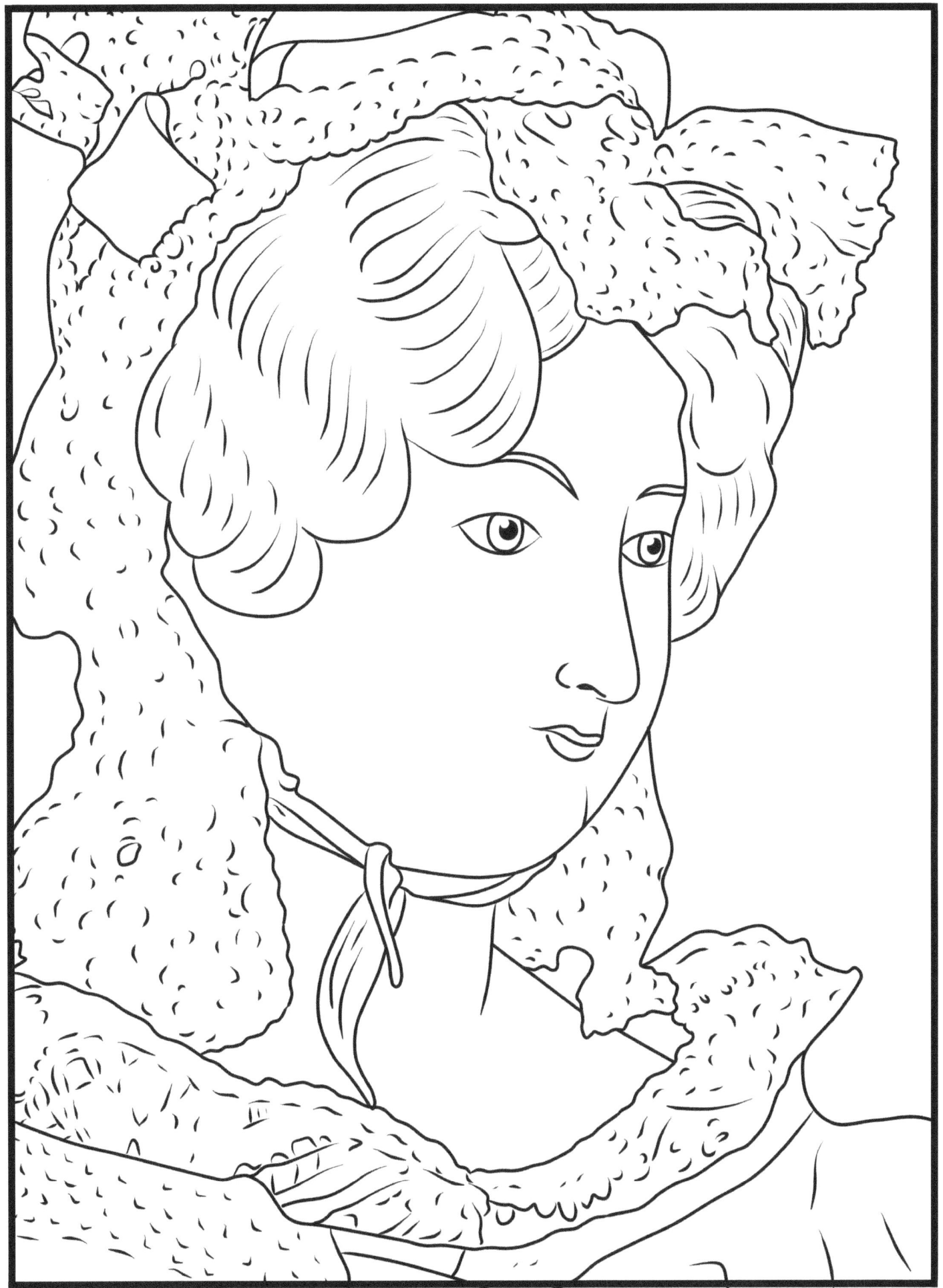

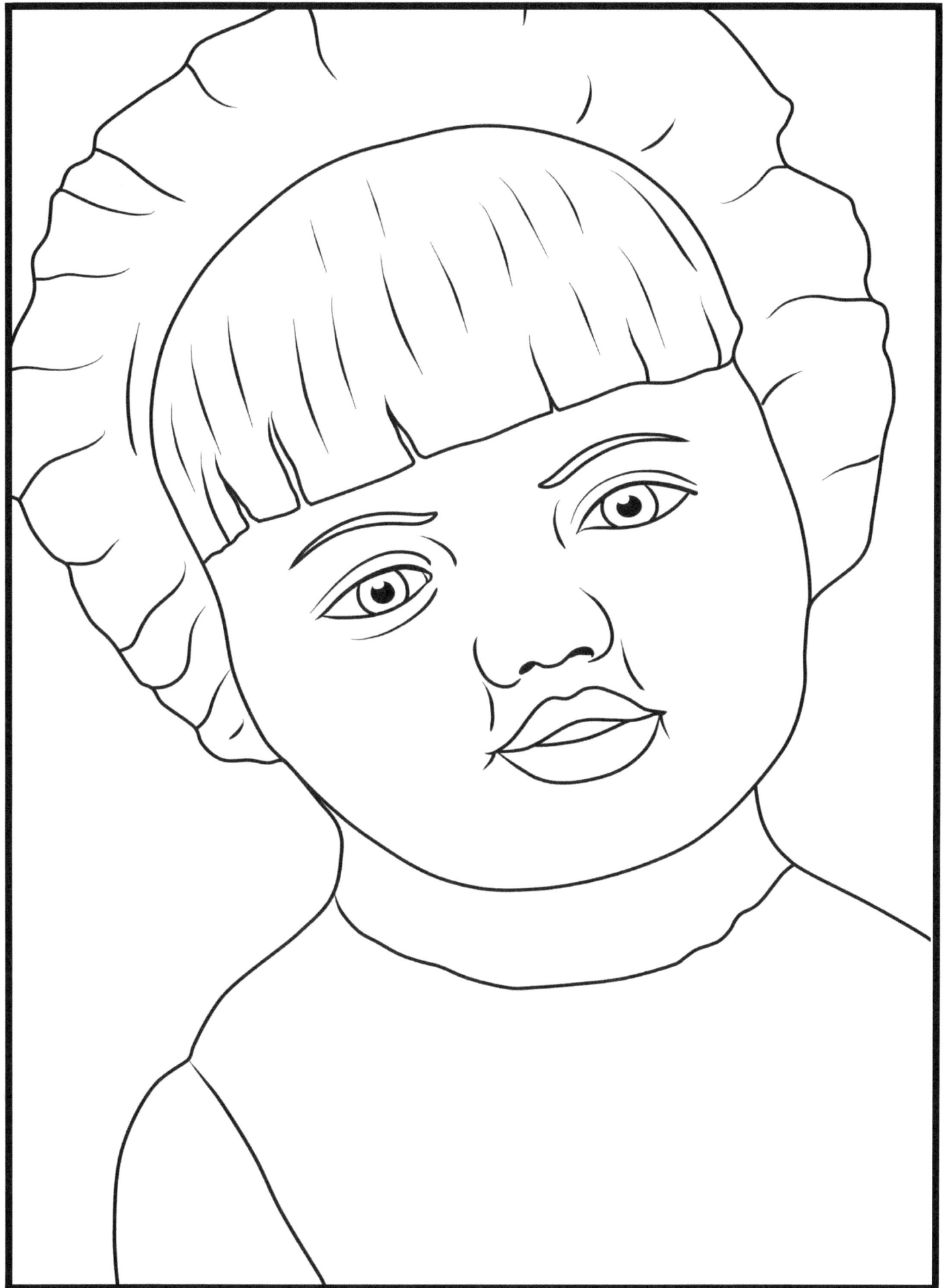

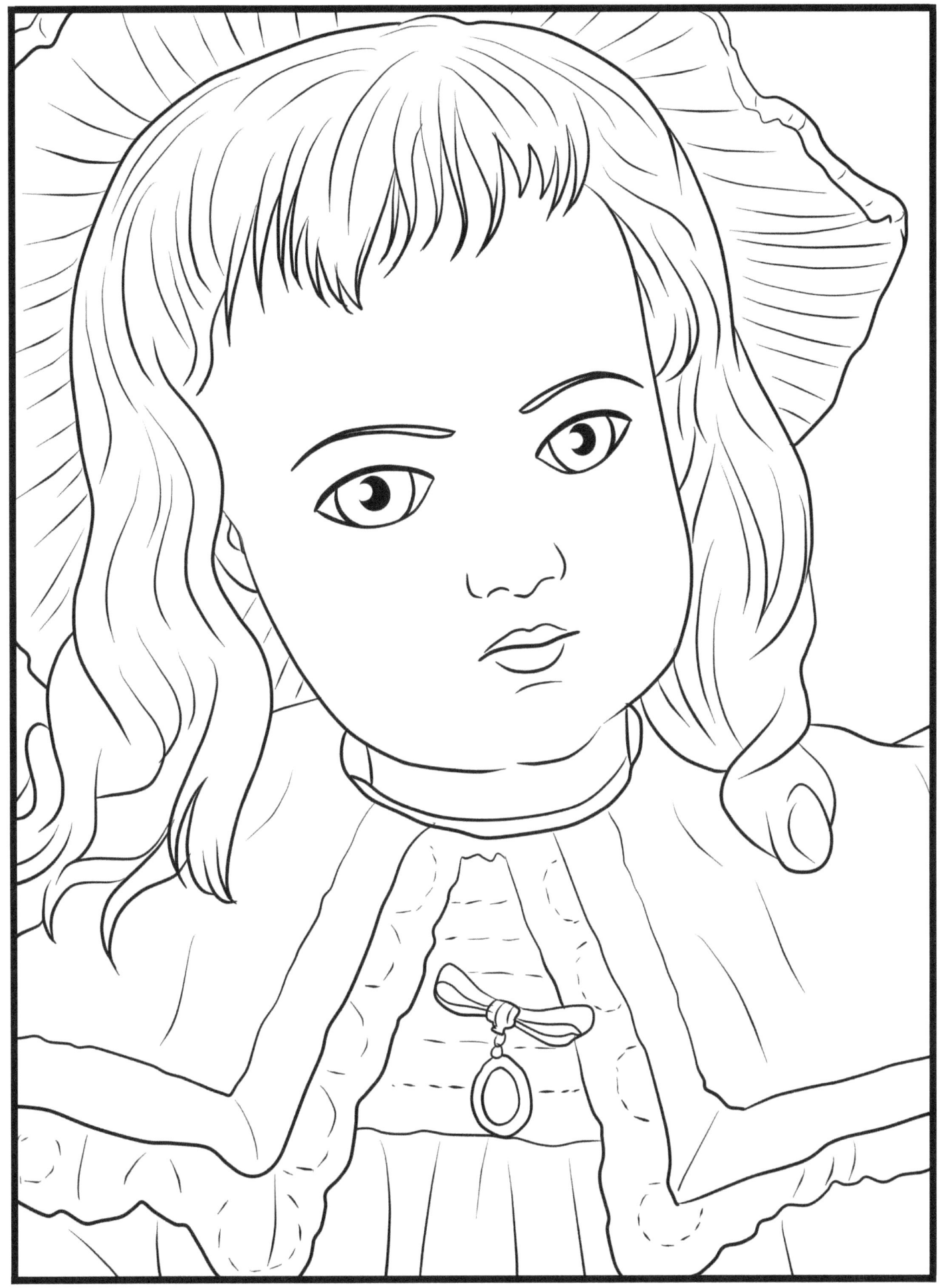

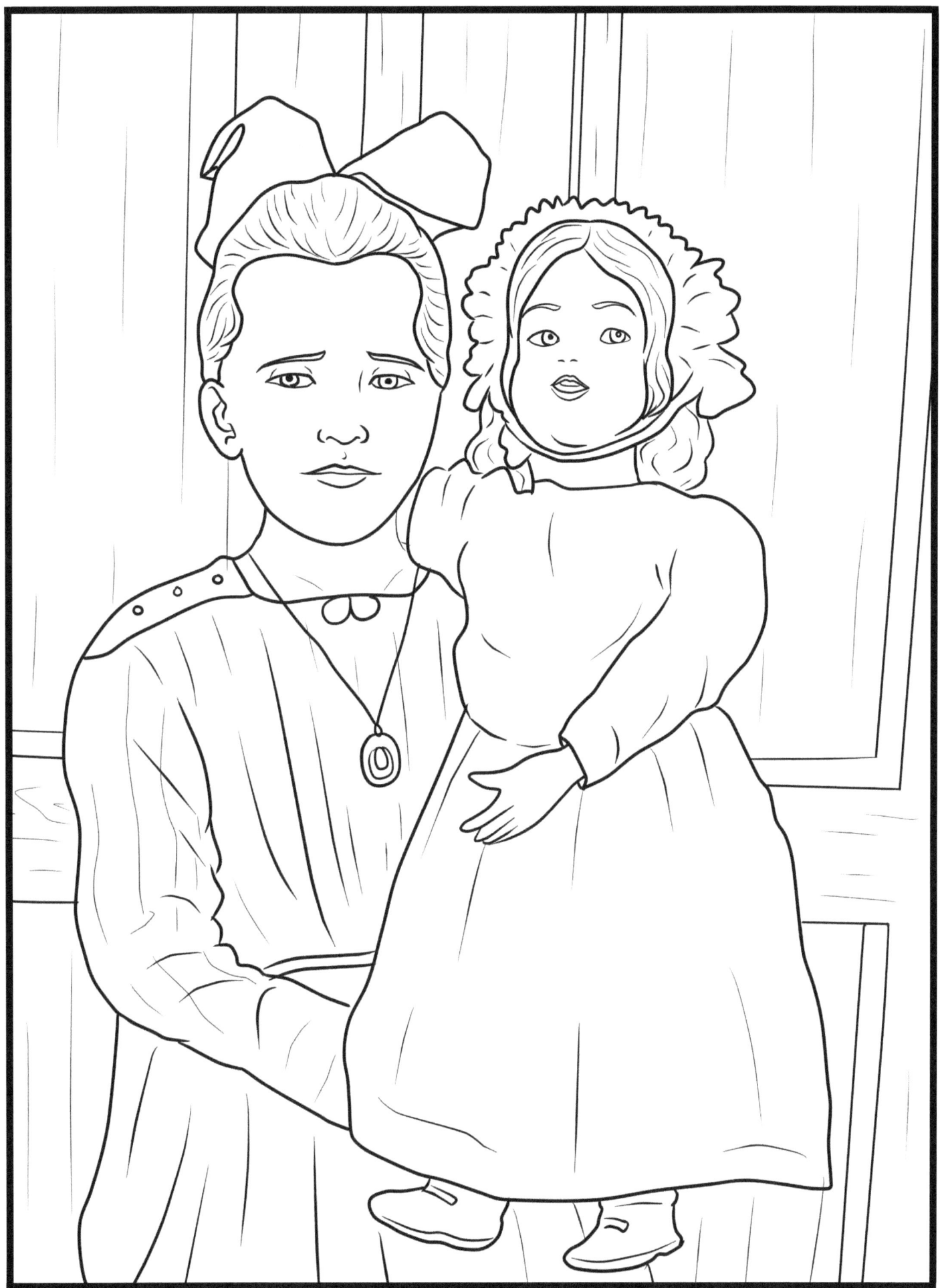

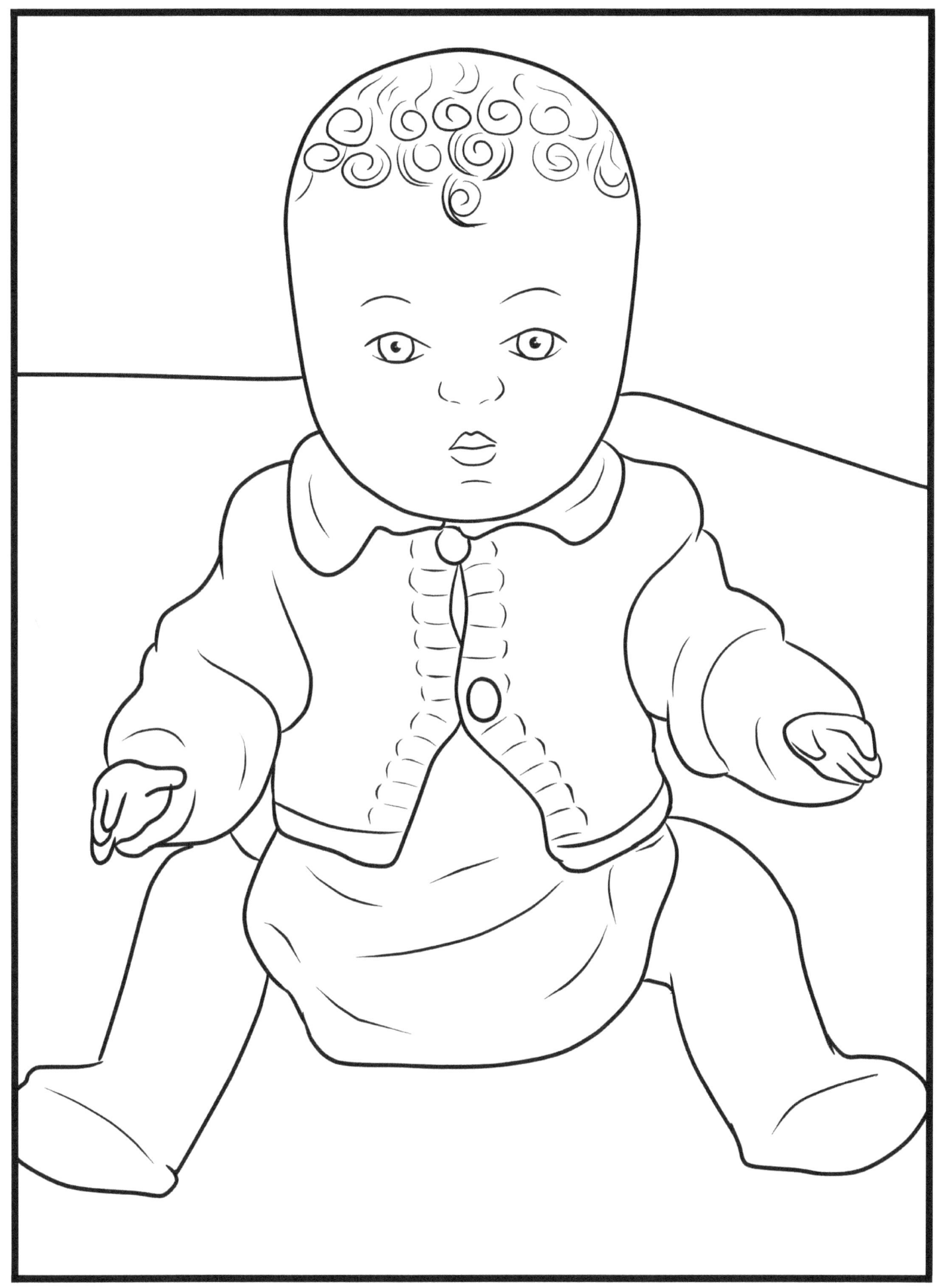

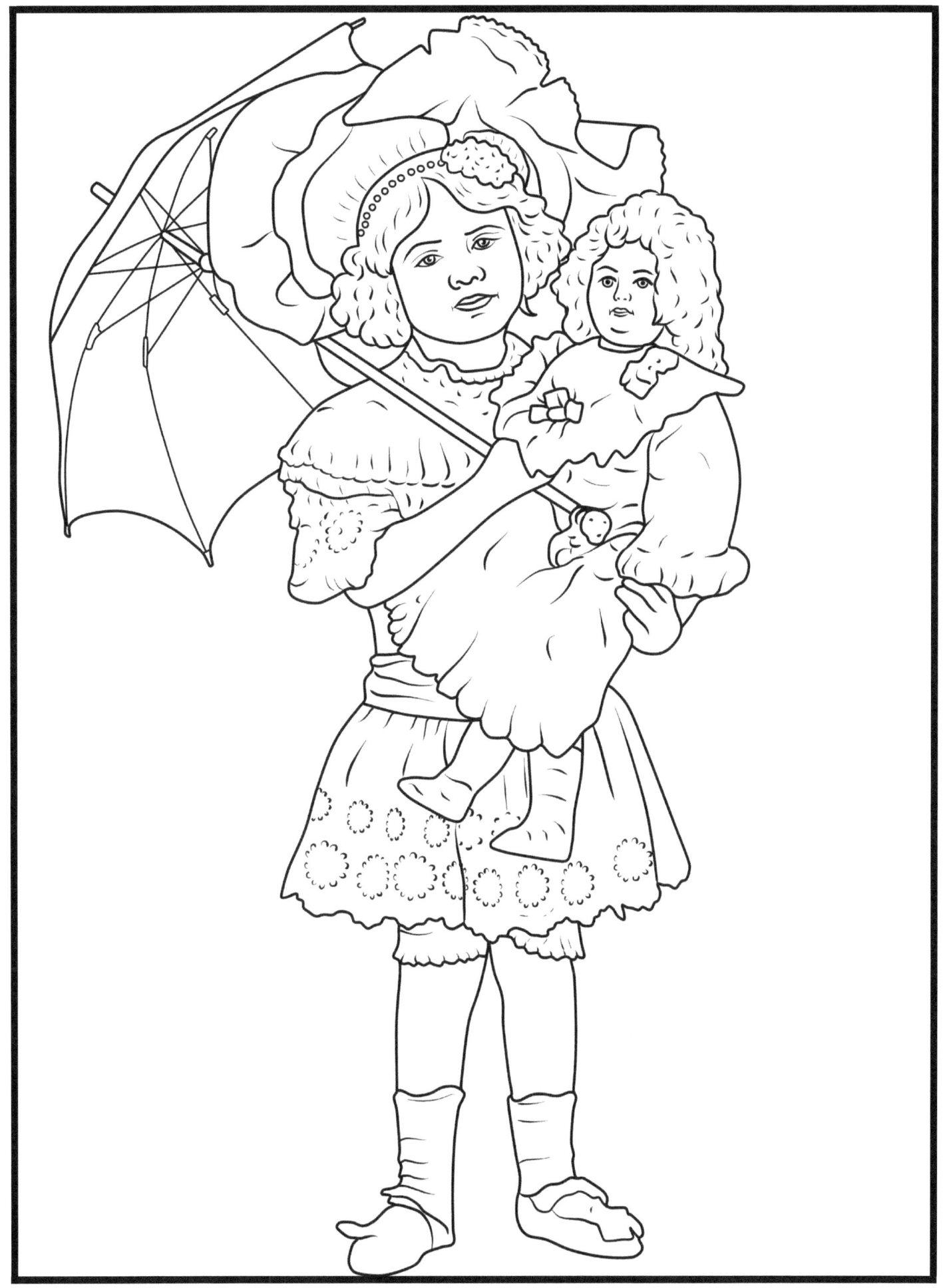

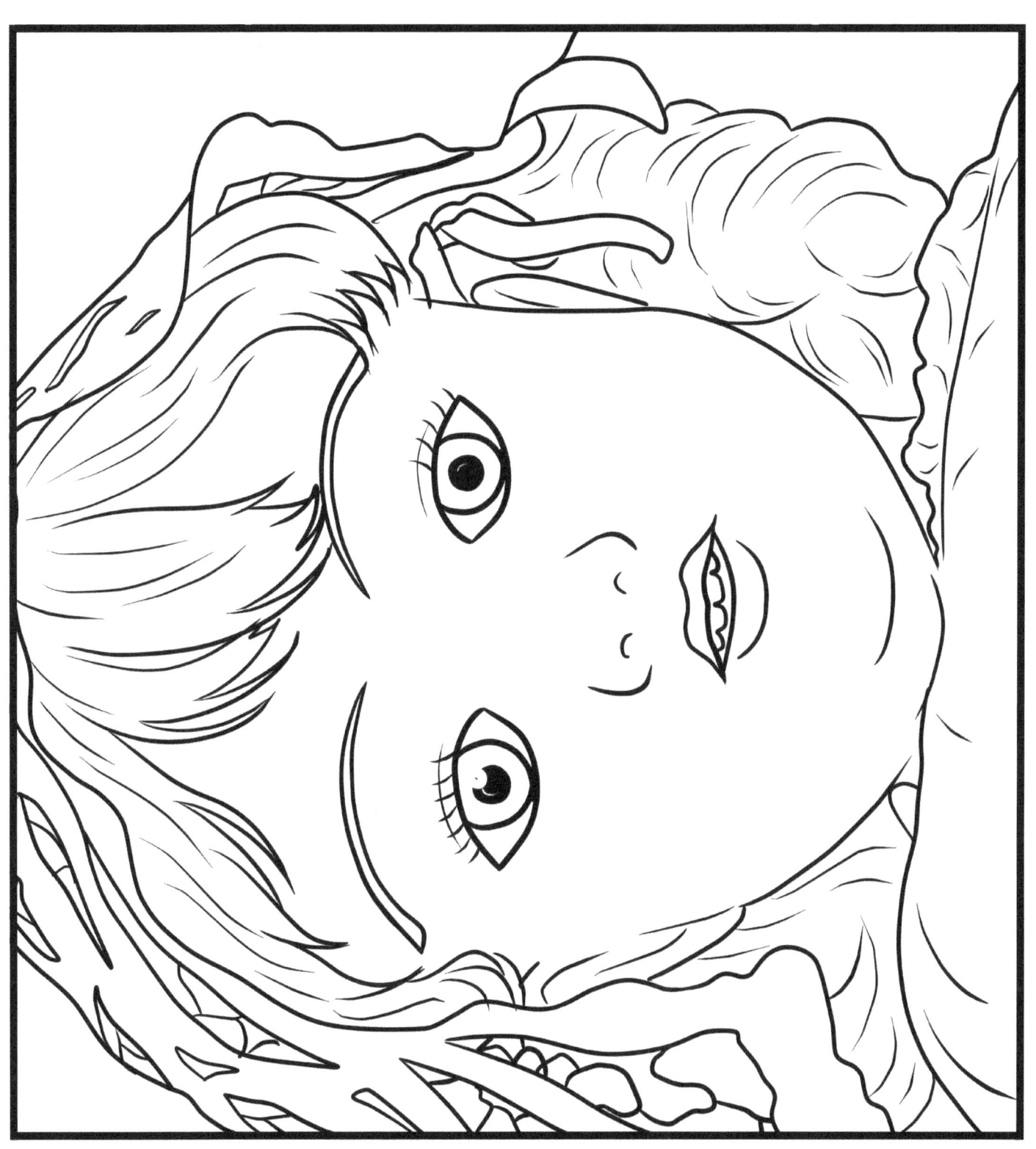

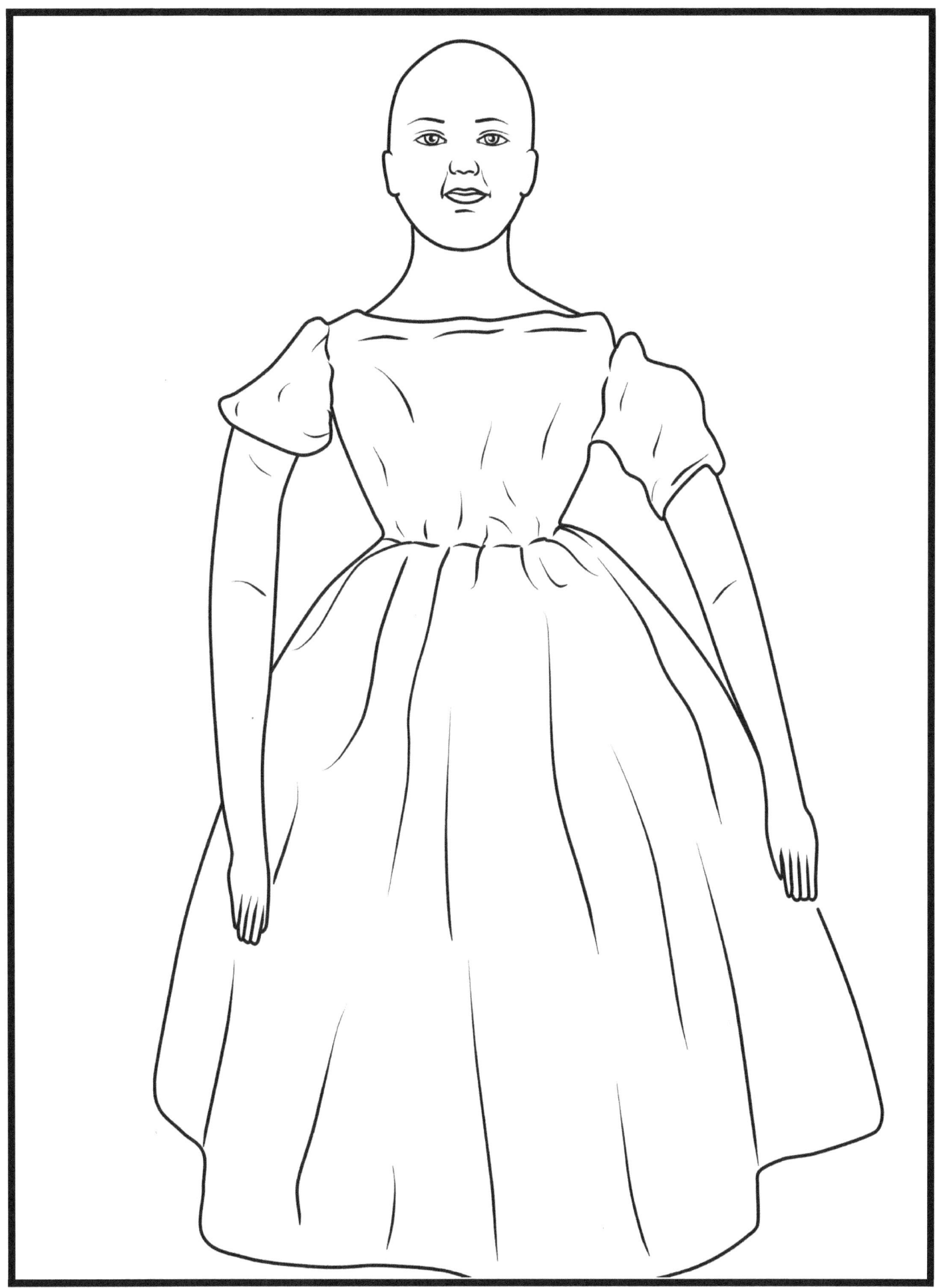

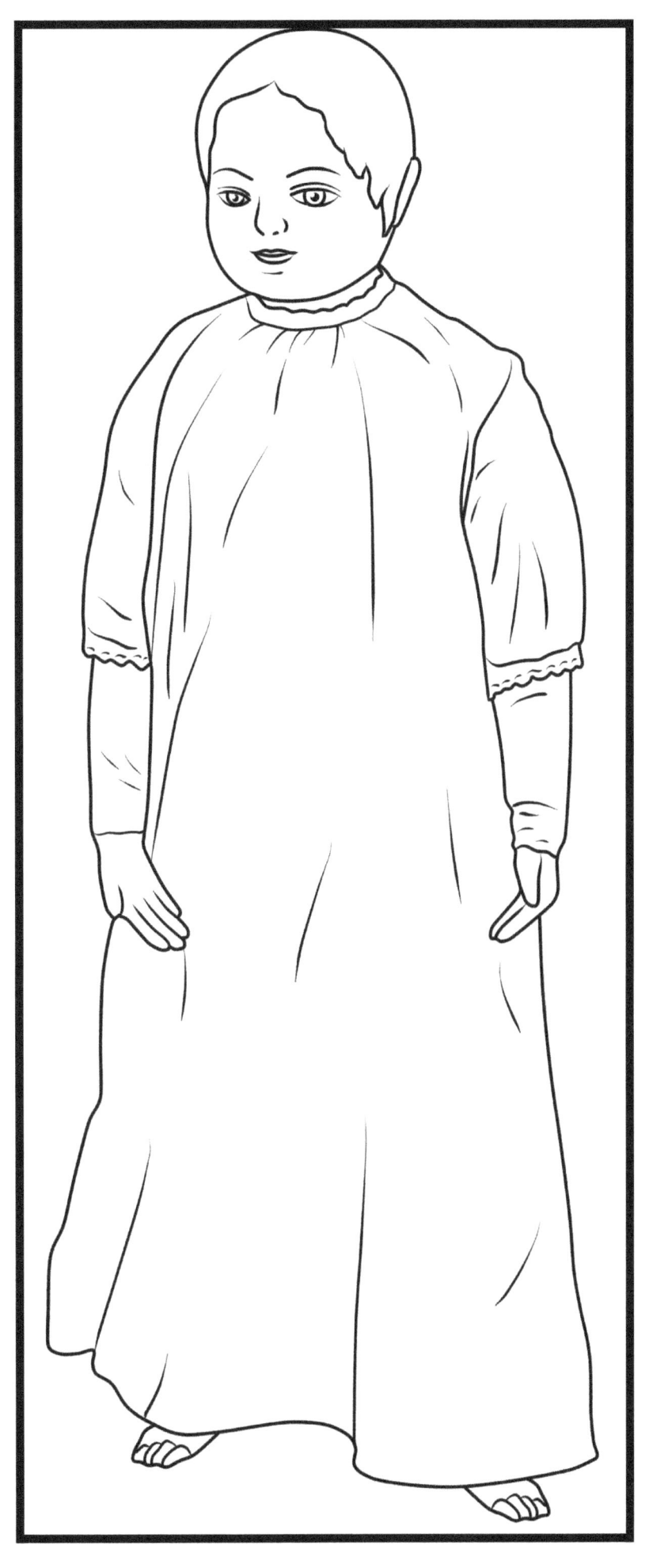

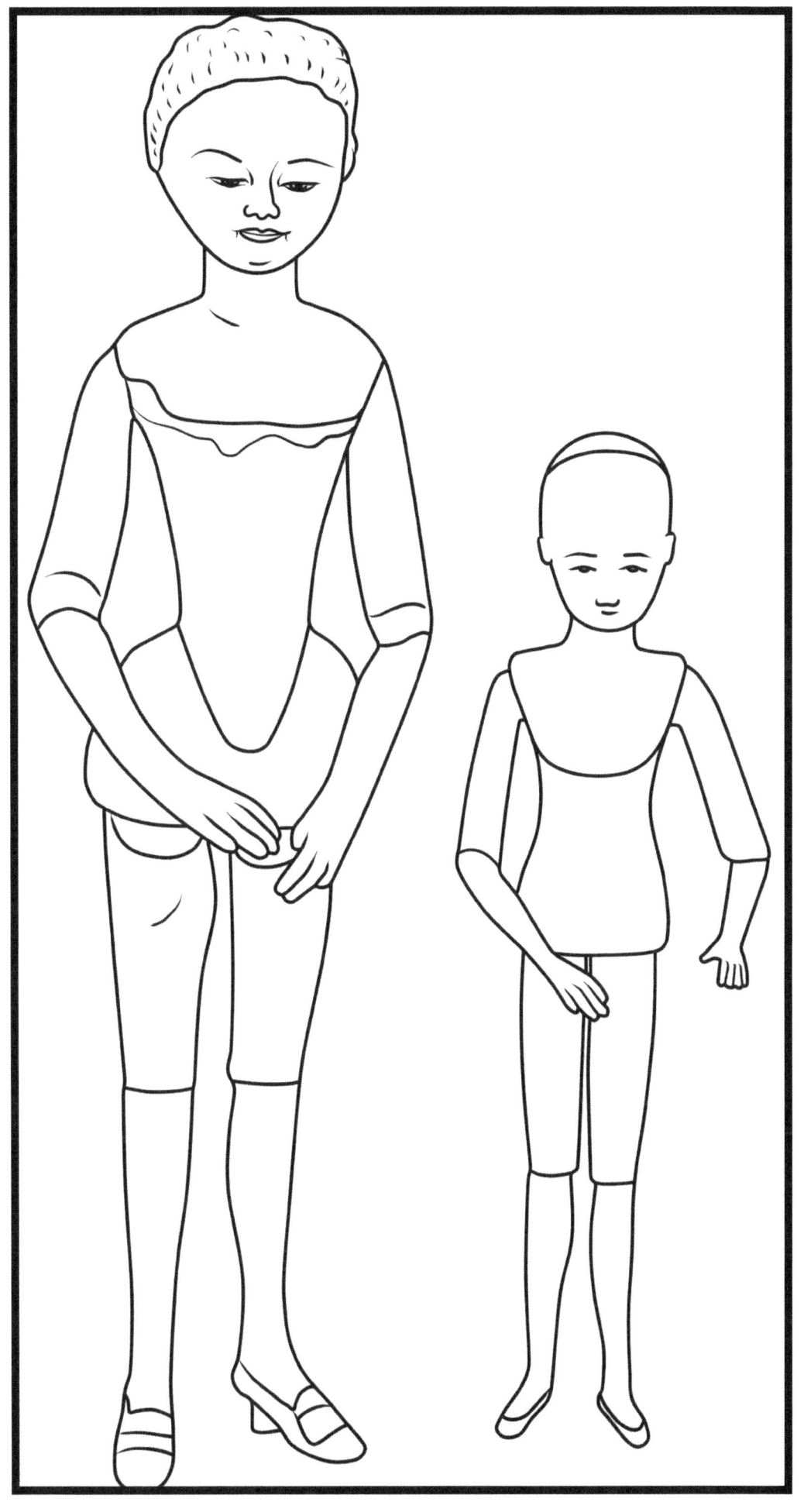

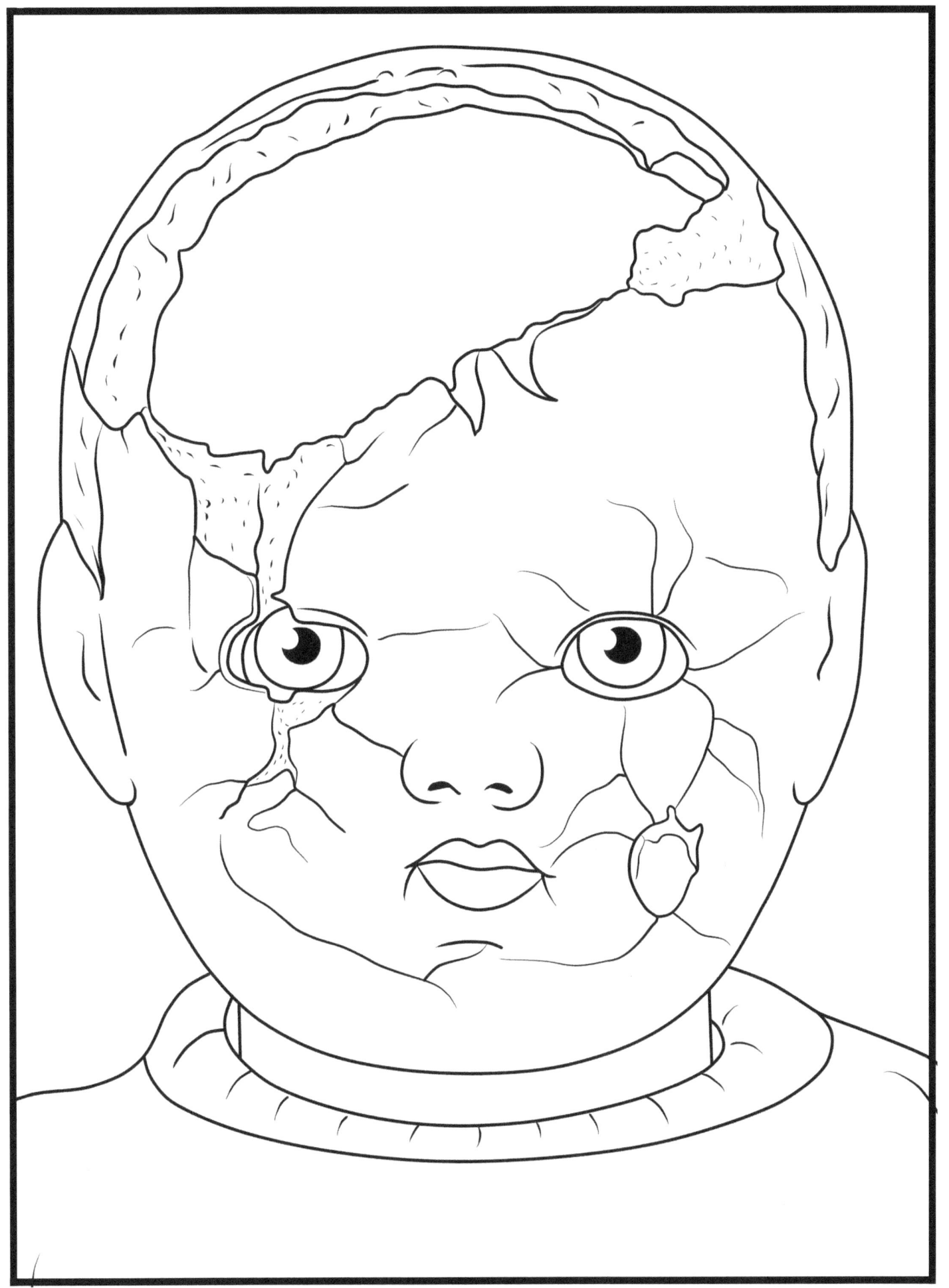

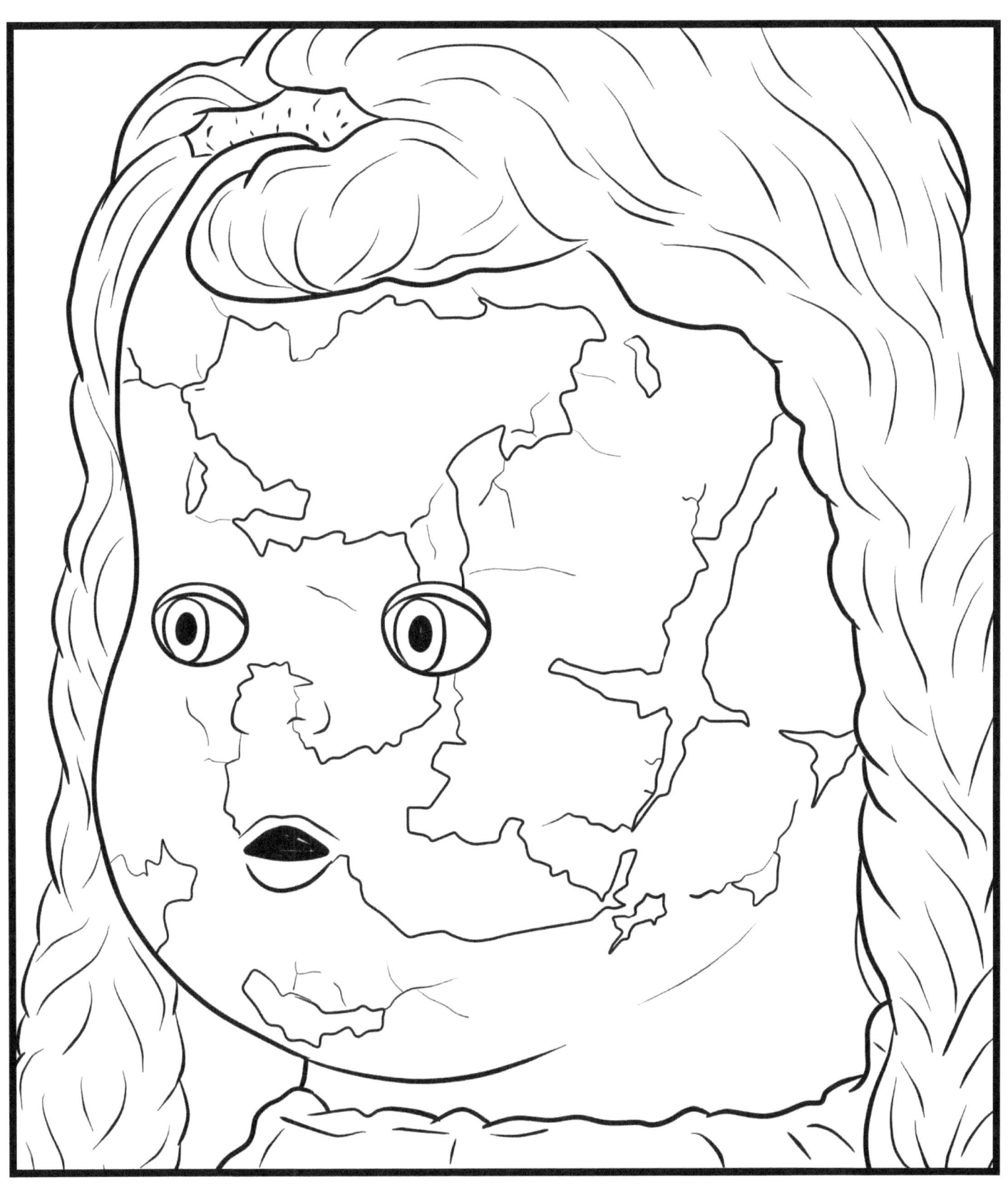

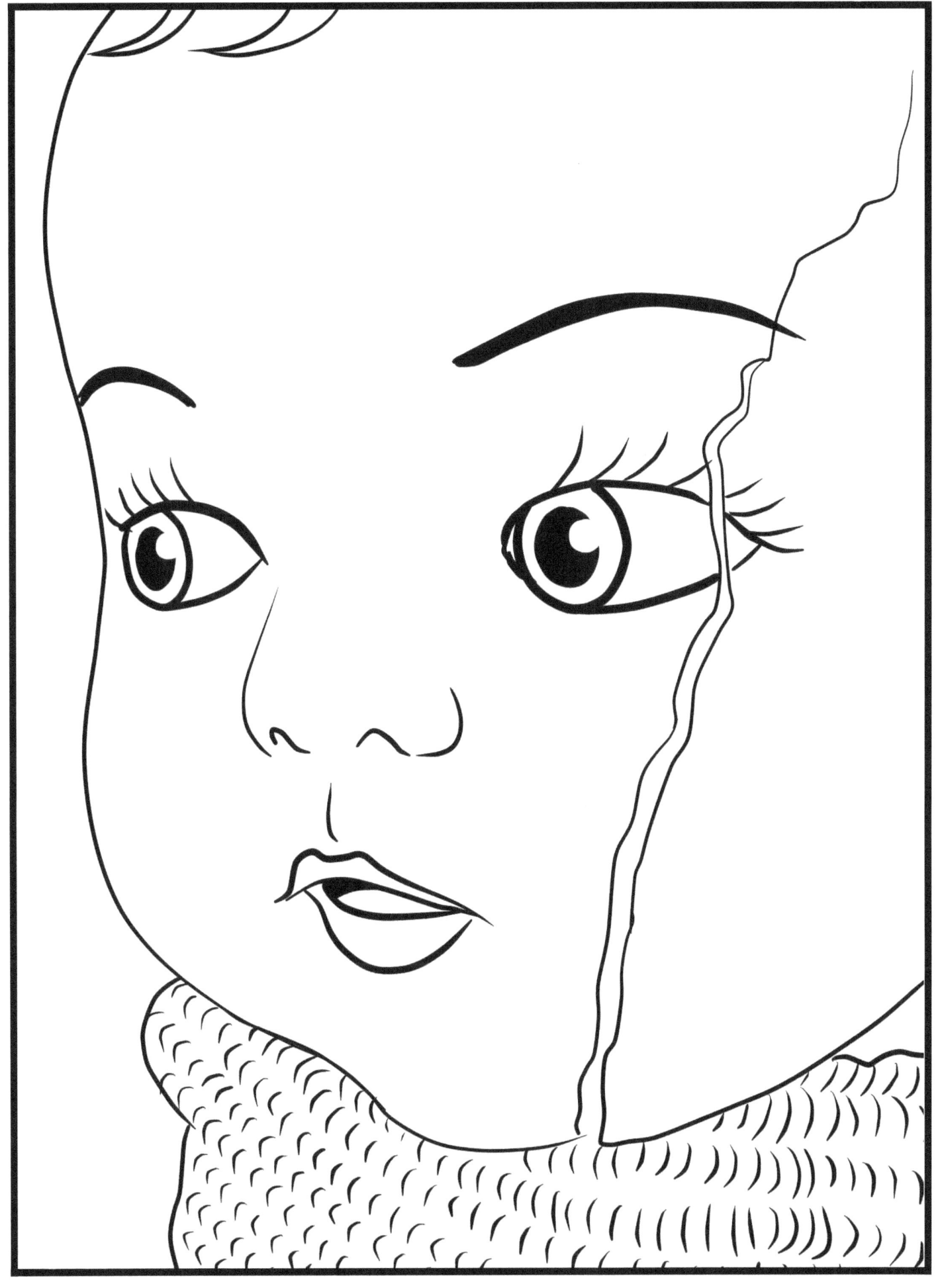

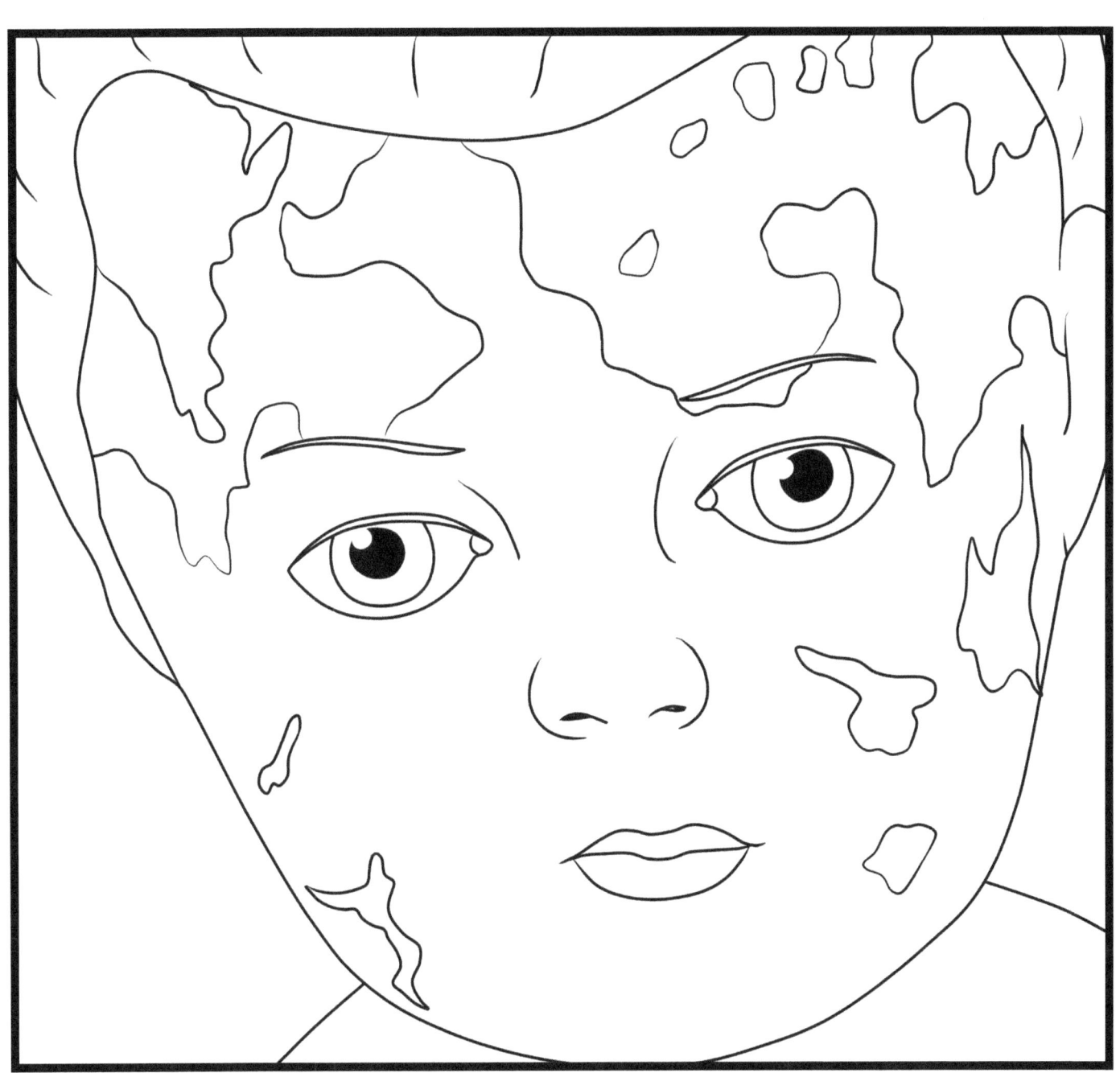

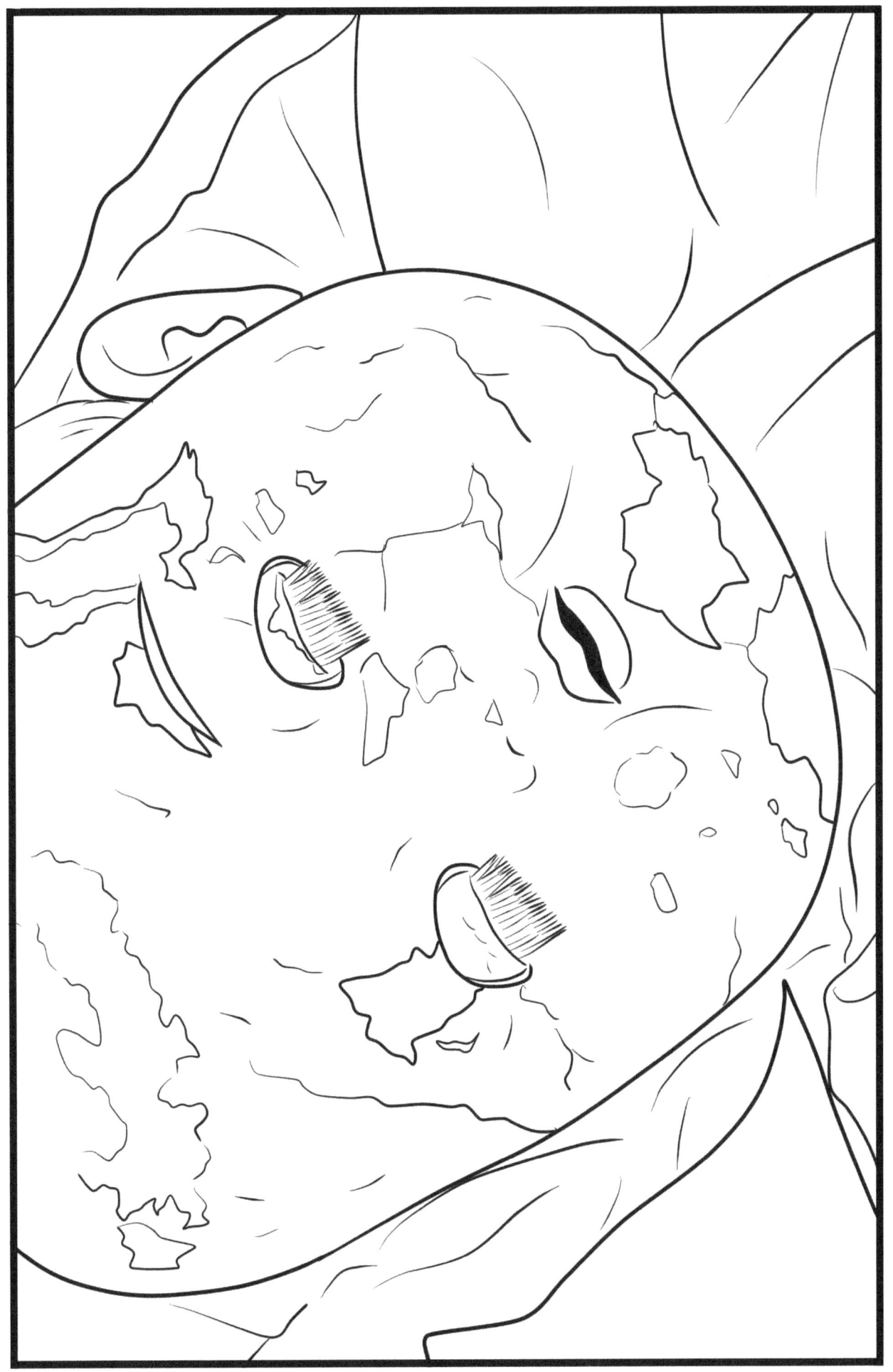

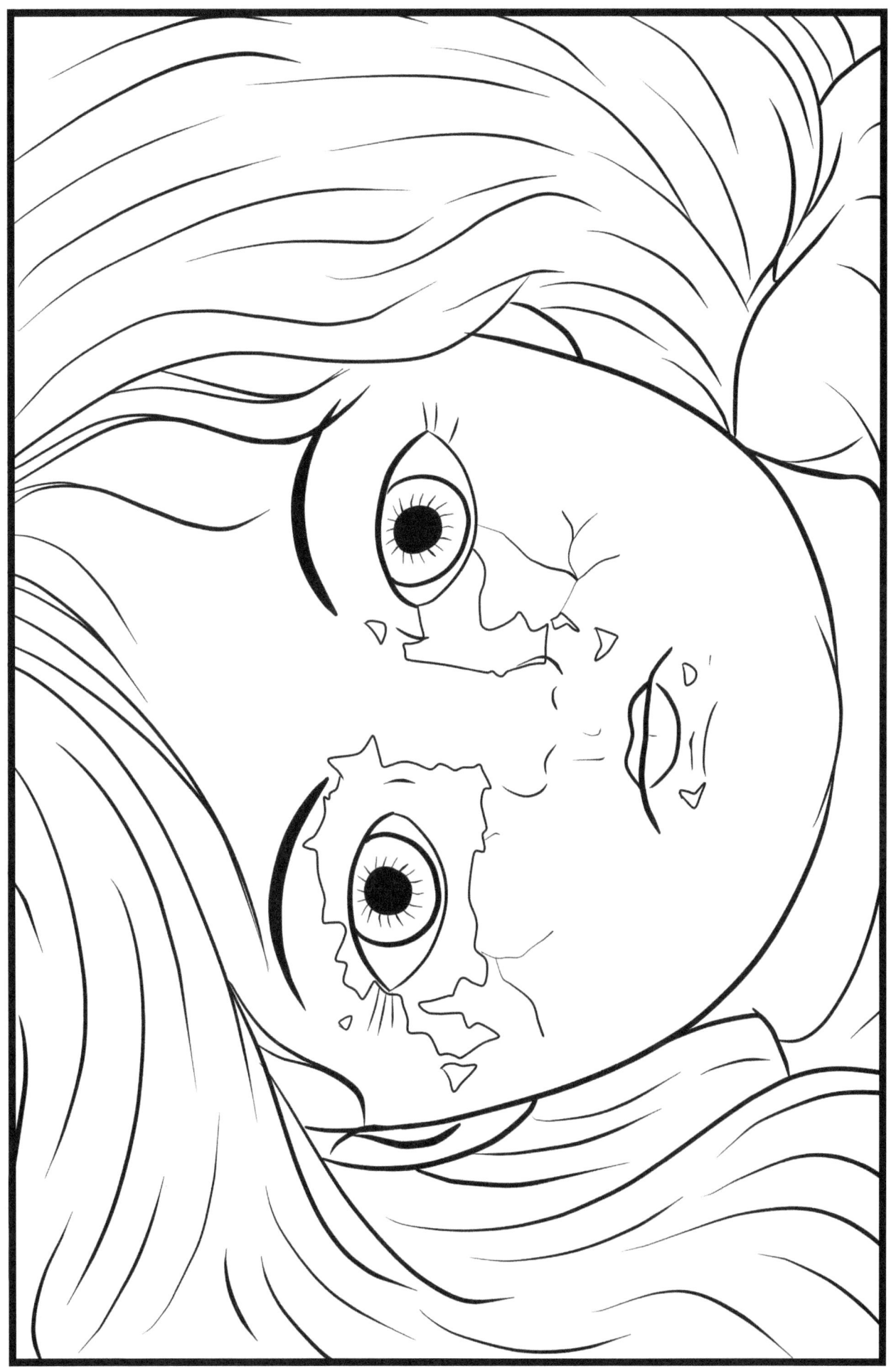

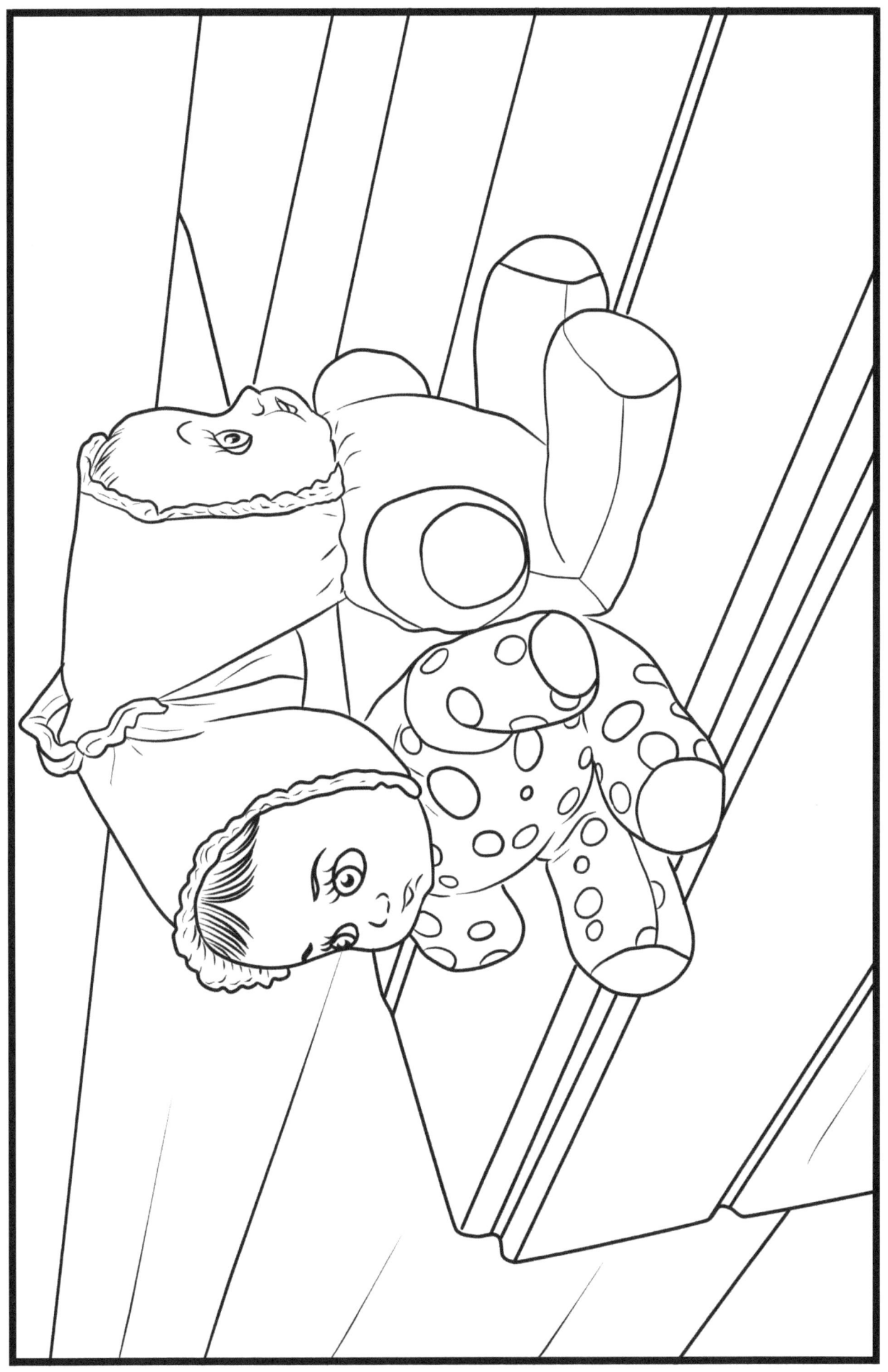

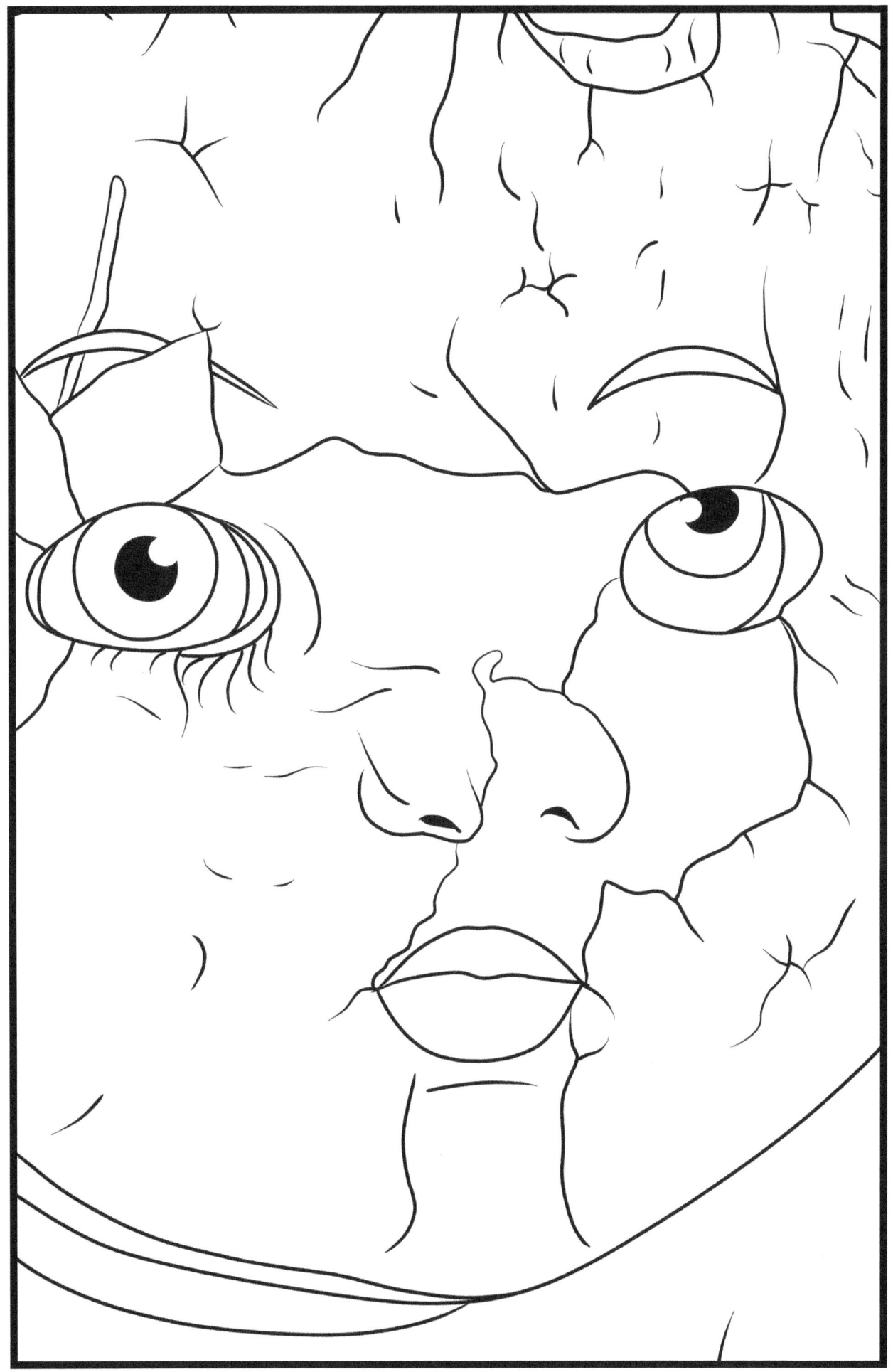

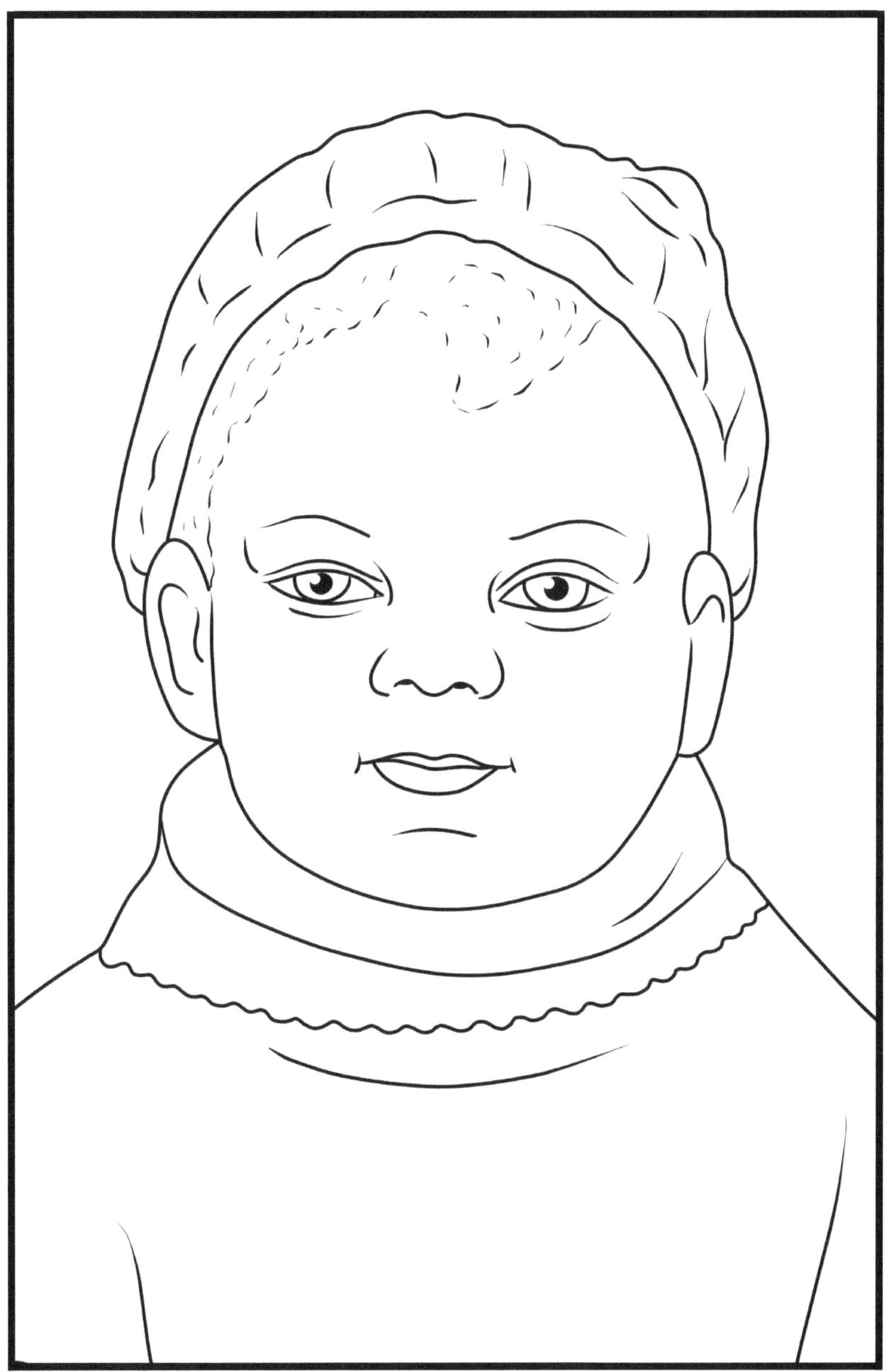

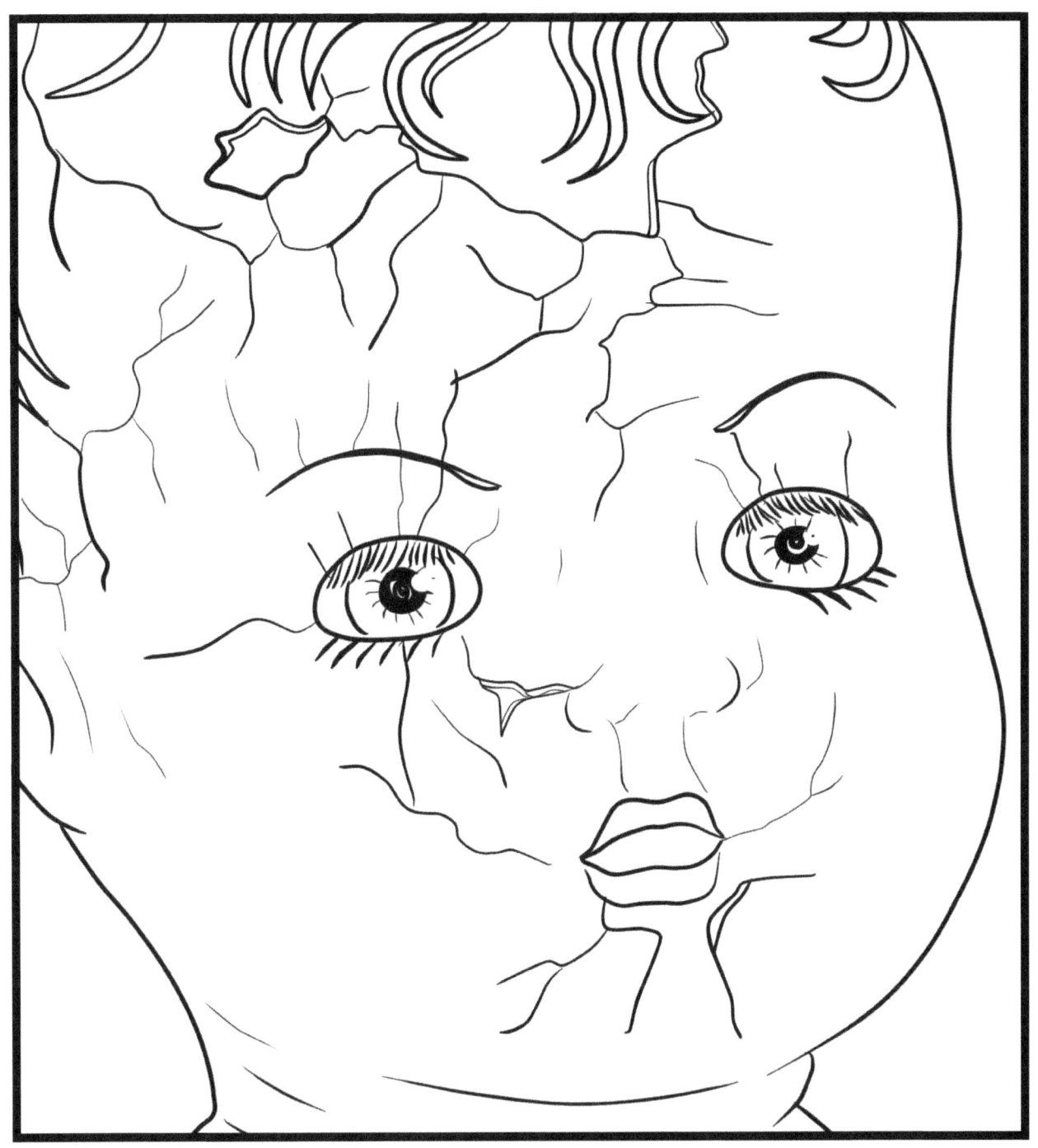

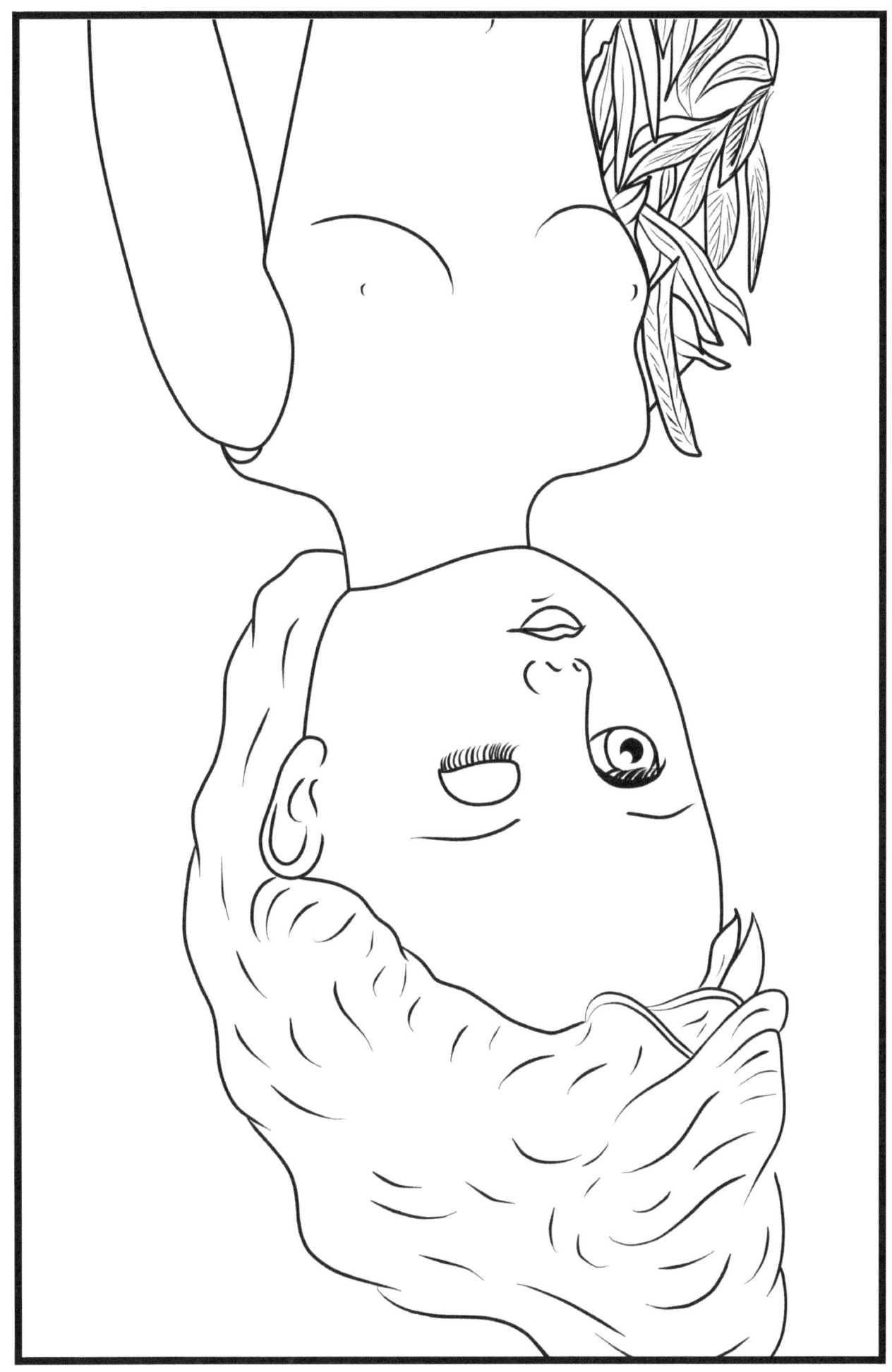

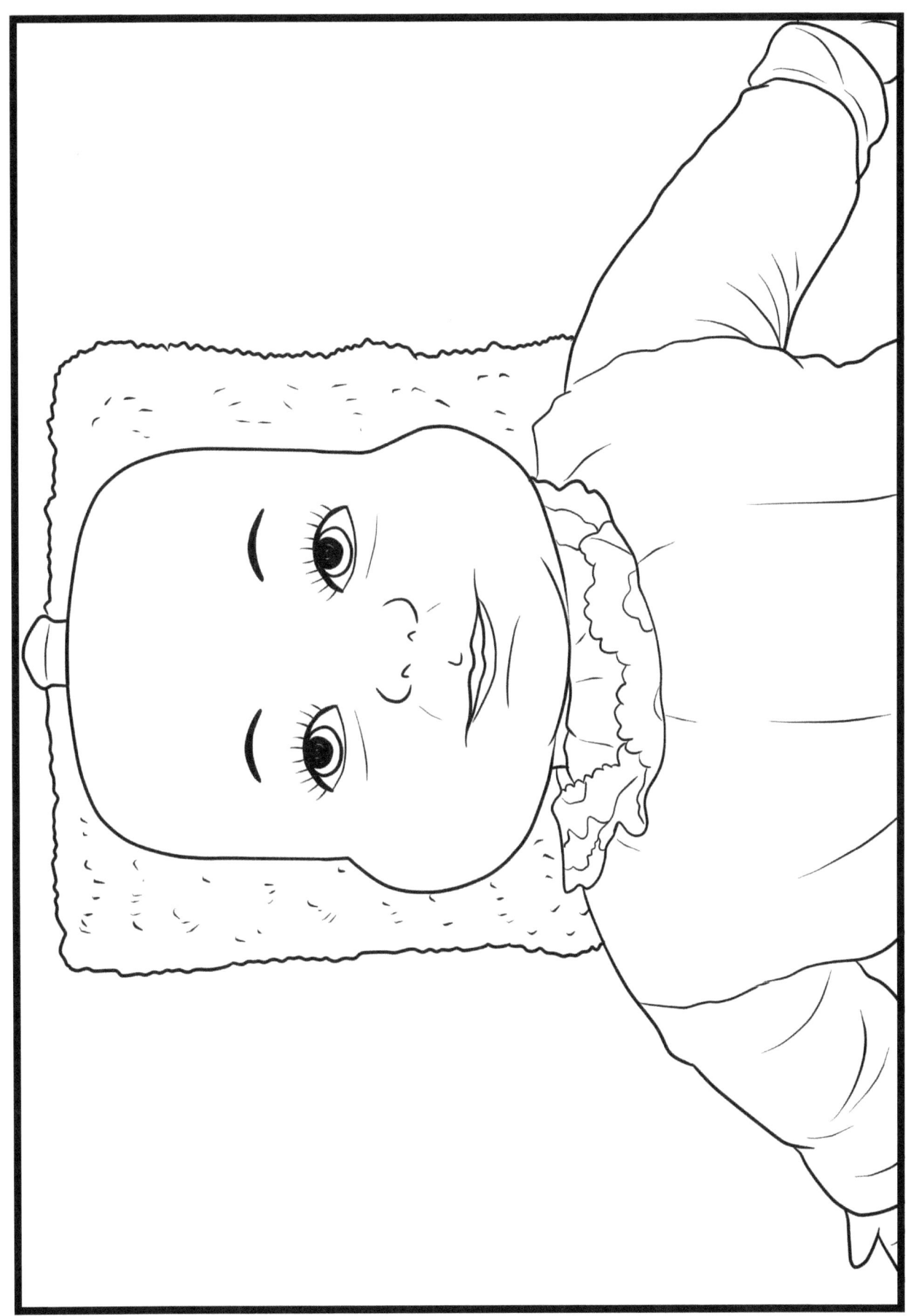

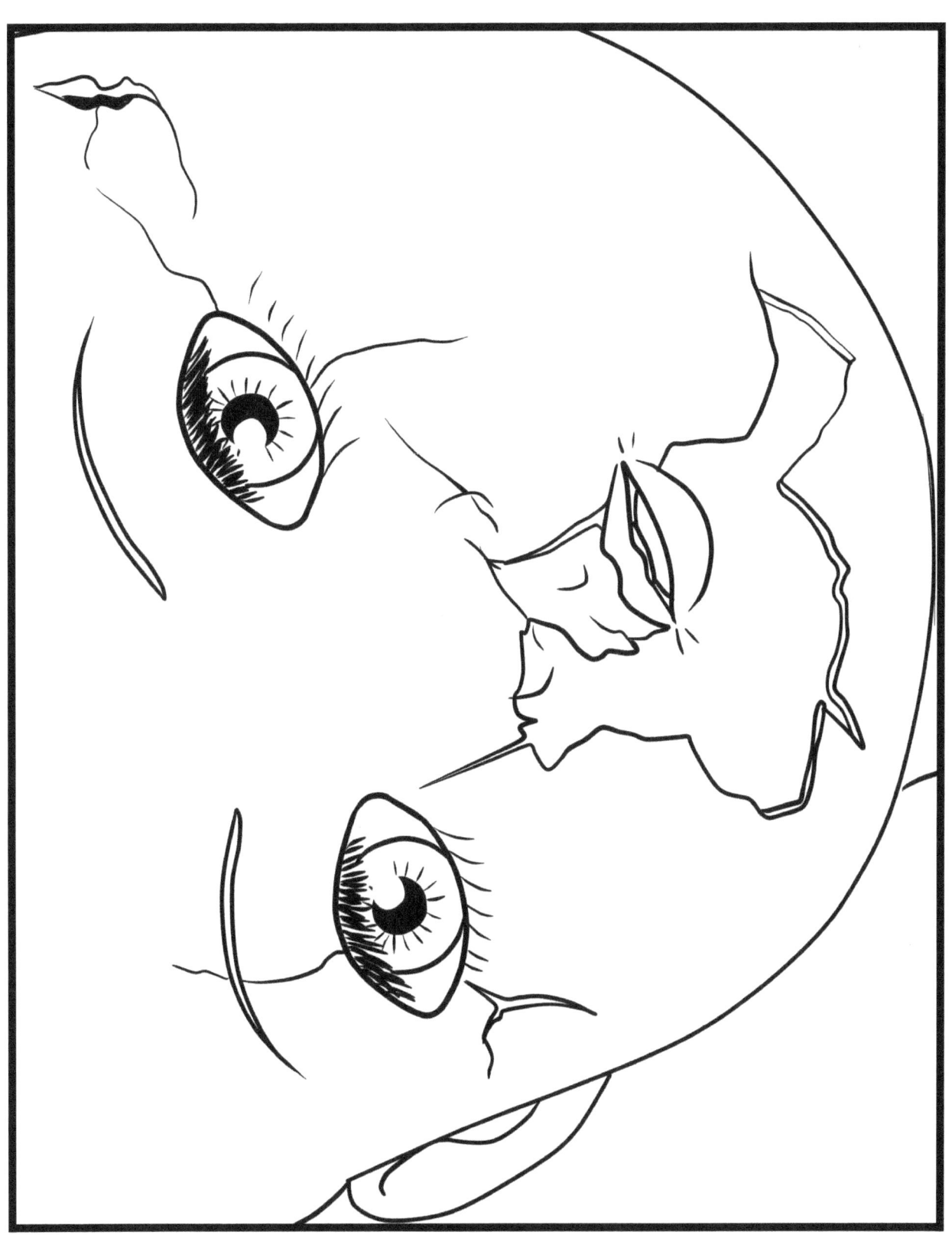

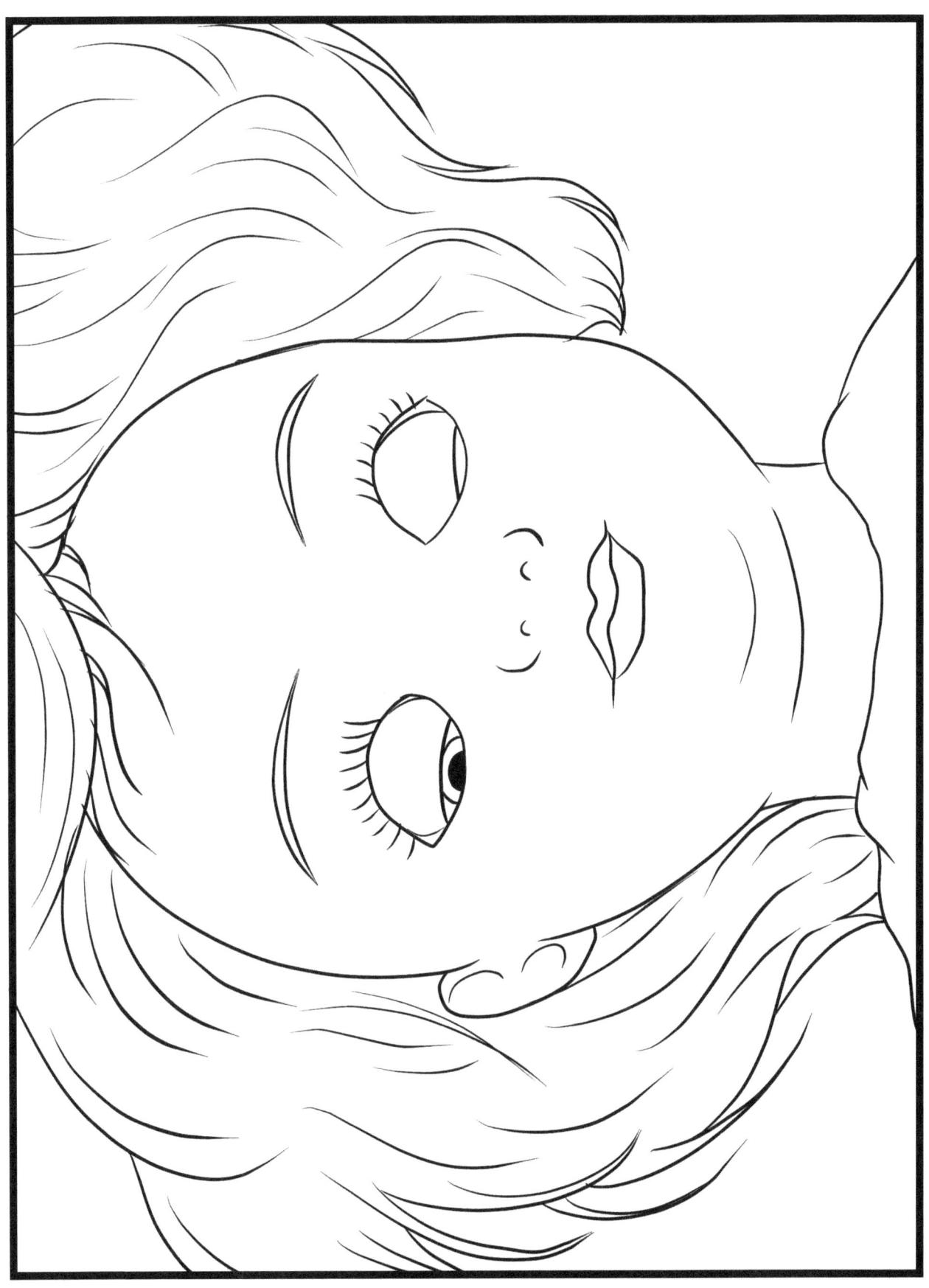

About The Author

Jordan Colton is an avid fan of horror & bad movies. Currently he resides in Utah with his cat & horror film collection.

Learn more about his coloring books at: www.HorridColoringBooks.com

Use the promo code "dahlia" for free shipping in the US.

Also check out his other coloring books:
Volume 1: The Night of the Living Dead
Volume 2: The Krampus
Volume 3: Manos the Hands of Fate
Volume 4: Creepy Clowns